the little book of drawing

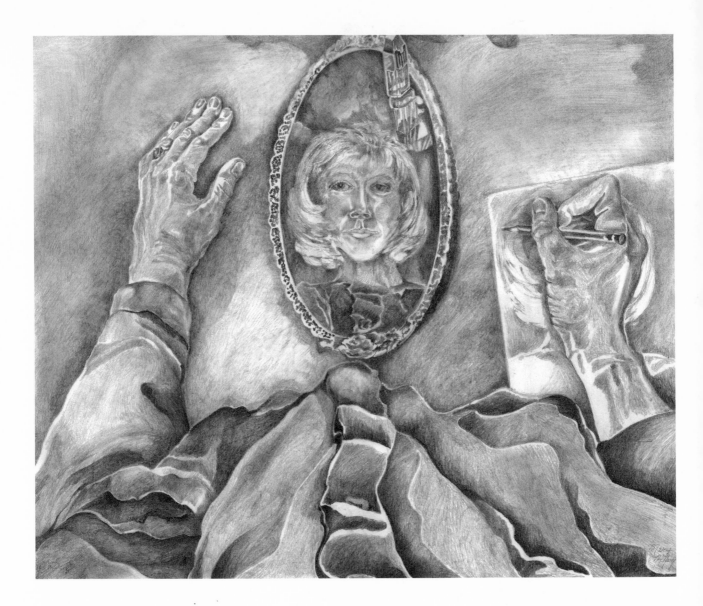

the
little book
of drawing

a friendly approach

Dr. Mary McNaughton

NORTH LIGHT BOOKS
CINCINNATI, OHIO
www.artistsnetwork.com

Other fine North Light Books are available from your local bookstore, art supply store or direct from the publisher.

11 10 09 08 07 5 4 3 2 1

Distributed in Canada by Fraser Direct
100 Armstrong Avenue
Georgetown, ON, Canada L7G 5S4
Tel: (905) 877-4411

Distributed in the U.K. and Europe by David & Charles
Brunel House, Newton Abbot, Devon, TQ12 4PU, England
Tel: (+44) 1626 323200, Fax: (+44) 1626 323319
Email: postmaster@davidandcharles.co.uk

DISTRIBUTED IN AUSTRALIA BY CAPRICORN LINK
P.O. Box 704, S. Windsor NSW, 2756 Australia
Tel: (02) 4577-3555

Library of Congress Cataloging in Publication Data
McNaughton, Mary.
 The little book of drawing : a friendly approach / by Mary McNaughton. -- 1st ed.
 p. cm.
 Includes index.
 ISBN-13: 978-1-58180-885-8 (hardcover : alk. paper)
 ISBN-10: 1-58180-885-2 (hardcover : alk. paper)
 1. Drawing--Technique. I. Title.
NC650.M44 2007
741.2--dc22
 2006038929

Edited by Jeffrey Blocksidge and Erin Nevius
Designed by Guy Kelly
Page Layout by Terri Woesner
Production coordinated by Matt Wagner

ACKNOWLEDGMENTS

I would like to pay homage to my early mentors in design education, Marion Ortoff Bagly and Eugene Larkin. I came to the design department from studio arts. I had the artistic skills but few answers to puzzling compositional questions. Through foundation classes that gave me a strong basis in formal design principles, Professors Bagly and Larkin provided me with the keys to a unique method of drawing instruction. I have adapted many of their insights and lessons to fit within the emotional aspect of studio art. Only then did I discover the answers to empowering my students.

DEDICATION

I would like to dedicate my book to my husband Patrick and my supportive family, from whom I have derived inspiration and sources for my drawings. They have provided me with a wealth of material and ideas. I would also like to thank my editors, Erin Nevius and Jeffrey Blocksidge, for giving form to my voice. And to my students; I have learned much from all of you.

METRIC CONVERSION CHART

To convert	to	multiply by
Inches	Centimeters	2.54
Centimeters	Inches	0.4
Feet	Centimeters	30.5
Centimeters	Feet	0.03
Yards	Meters	0.9
Meters	Yards	1.1

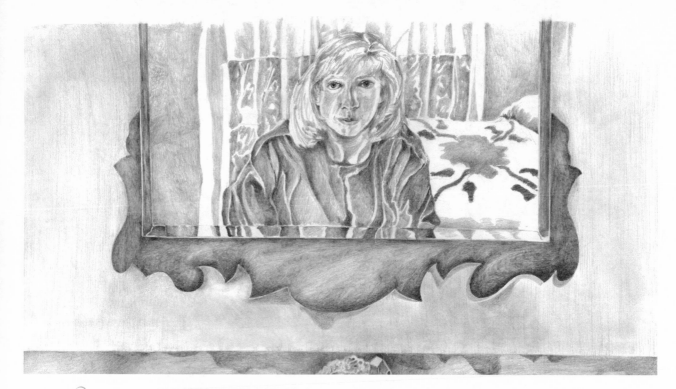

ABOUT THE AUTHOR

Dr. Mary McNaughton's experience with drawing and painting is extensive. While raising her children she began her career by exhibiting paintings in oil and watercolor. While at the University of Minnesota she earned a B.A. in Studio Art, a Master's in Design and her Ph.D. in Applied Design Research. Her emphasis throughout her studies has been drawing. Dr. McNaughton has taught within the Minnesota Community College system and the University of Minnesota and its outreach program for fifteen years. The past three years she has spent researching and writing on the subject of drawing. While lecturing and sharing her passion on this subject she has developed a considerable following of students. She currently exhibits her own work using the principles she has taught for many years.

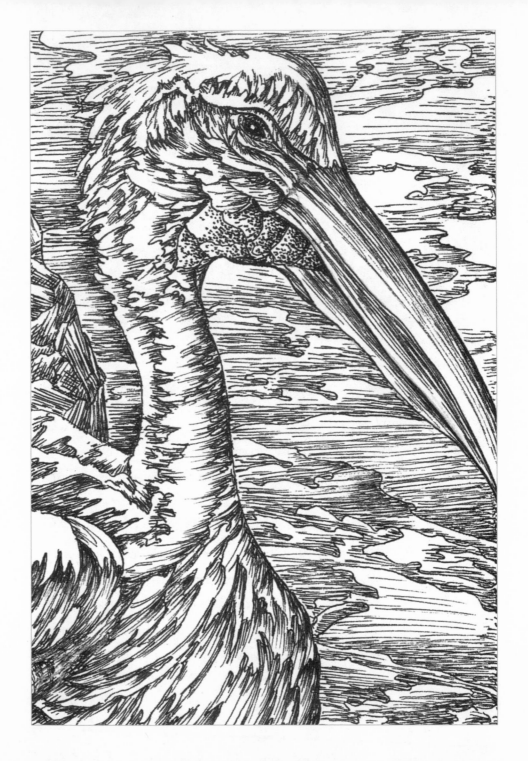

contents

introduction

For those who are serious about learning to draw and wish for a "friendly experience," this is the book. It will tell you everything you need to know about compositional choices and technique; yet it goes much further by molding you into an informed artist who can edit from visual settings and make wise choices within a vast array of subject material.

Those frustrated by a cold classroom experience or who read manuals with only partial explanations will find this book to be an invaluable tool. It's meant to serve as an interactive drawing course that can be put down, picked up and give feedback whenever you like. You are treated with respect, encouraged to explore your unique way of drawing, and empowered through every step of the process.

Too often, aspiring artists are met with cold, elitist methods that leave them feeling as if art were relegated only to a talented few. If taught properly, drawing can be learned just as playing a musical instrument can be learned. Not everyone will be a virtuoso, but if given the proper time, dedica-

tion and appreciation of the power of the contour drawing as an emotive tool, each of us can learn to draw proficiently, invoke a personal style and master the medium. My techniques instill the knowledge needed to achieve these goals.

Because the text is structured to read as if you're with me in my classroom, I speak in the first person. My style of teaching is inclusive, allowing the discipline of compositional concepts to join with emotional personality. The product is a truthful expression that is unique to each of us.

All of my experience with drawing leads me to frustration with the methods of instruction available. By pairing the discipline of design with the emotion of studio art, my instruction method leads the student on a journey of enlightenment and self-discovery.

The contour drawing is the key to unlocking the mystery of drawing. It's not just a right brain activity. The planning of the left brain allows the freedom and emotive nature of the blind contour process to express itself.

starting materials

Refer to this list from time to time as you choose from among the many products available at the art supply store.

Graphite pencils: Five or six drawing pencils; recommended leads include 4B, 6B, 8B, HB and 2H. The B leads get progressively softer as the numbers get larger and the H leads get progressively harder. HB is the medium. Try a variety.

Charcoal: Two or three sticks compressed charcoal. These will come in different degrees of hardness. Compressed sticks will serve you better than pencils in the beginning. Vine charcoal is much looser and used for freer sketching; it will fragment easily. Be sure to get some spray fixative.

Tortillions or blending stumps: These are used to blend the more movable mediums such as charcoal and pastel.

Conté crayon: One black and one white. These are wonderful for blending with a variety of mediums such as pen and ink, charcoal and pastel.

Pastel pencils: Two or three in gray, black or white. These can be used with charcoal or on their own.

Black ink pens: Two fine or extra-fine point and one medium point.

Pencil sharpener: It's wise to find a hand sharpener with a case to catch the shavings when working on site.

Kneaded erasers: Shape these to reach tiny areas. Use them for drawing and blending, not just correcting. (They can also be bounced off walls when you're frustrated.)

Drawing pad: Strathmore, Arches, Rives and Fabriano are just a few of the brands available. You'll need a pad about 18" × 24" (46cm × 61cm).

Drawing and charcoal paper: Six or seven sheets of cotton rag paper 22" × 30" (56cm × 76cm) approximately 125-lb. (266gsm) weight. Hot press has a smooth surface. Cold press is more textured. For this book, start with hot press.

Drawing or clip board: One laminate board with large clips and an opening for carrying paper, approximately 24" × 26" (61cm × 66cm).

Camera: For taking reference photos to help you with compositions. The brand and features are up to you.

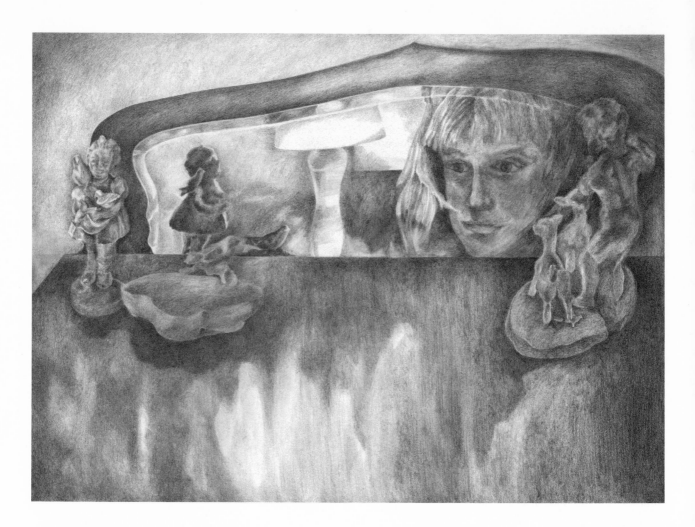

what is drawing?

How do we define drawing on an emotional level? From the time that most of us are able to put together articulate thought, we attempt to express ideas through our markings.

We start by scribbling, doodling and laying down small sketches. But these are personal

notations rarely meant to be viewed by others. Perhaps it is because of this intensely private

relationship we have with drawing that it is a self-revealing process. We must bear in mind

that each one of us has our own unique personality that's revealed through our renderings.

We draw what we are, and we are what we draw.

why do we draw?

When civilization was young, drawing was used mainly as a tool for record keeping. Cave pictures, hieroglyphics and funerary art were a means of marking time, depicting significant events or paying homage, re-creating the life of an important person or culture. Rulers throughout time have used their wealth and power to commission and collect works of art. Without them, the world might have been deprived of many artistic treasures. However, above all, drawing represents a means of communication.

WHY SHOULD WE DRAW?

Drawing is still used today as a means of communication, a tool for dialogue or instruction—you see it in signs, posters and graphic art every day. Certain drawn symbols are readily recognizable. The pictures provide instruction to stop or go, tell us which restroom to use, which roads are slippery, and on and on. Such symbols are universal.

But why should we draw for ourselves? First, the desire to create is instinctual. It's a common trait of humanity to want to draw. All children draw. I know I have always drawn. On the next few pages are some of my first drawings from when I was young.

Responding Is an Instinct

When I was young, rendering what I saw was a means of connecting with my surroundings.

Patience
Learning to use value gradations
came slowly.

The Road to Self-Awareness
When I liked what I saw I tried to recapture it. I wasn't aware of
personal style until much later.

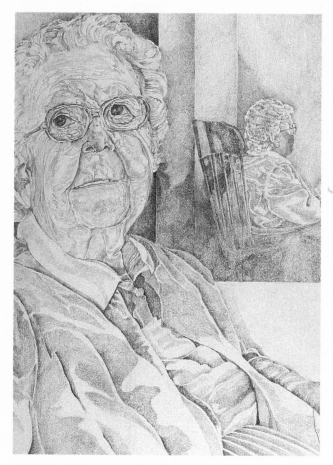

Hazel: A Close Examination
Hazel was a subject I knew very well because she was my piano teacher
for many years. Drawing her was a soothing and meditative process.

finding
yourself
in drawings

The intensely personal nature of drawing is one of the fundamental reasons for pursuing it. Putting pencil to paper is one of the processes we use to truly reveal and connect with our inner selves. The drawing process is stripped of interfering elements—it's just you, the tools and the subject at hand.

Learning to let yourself draw is fun. Allow yourself the freedom to reveal what's unique about you. Most important, let your drawings tell your stories and open a connection with your inner self.

This series of drawings gave me a strong sense of connection to my dear friend Hazel.

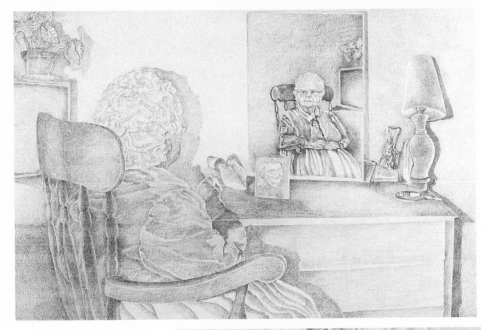

Looking Into the Mirror
Hazel's traits were revealed through her expressions and the setting of the nursing home.

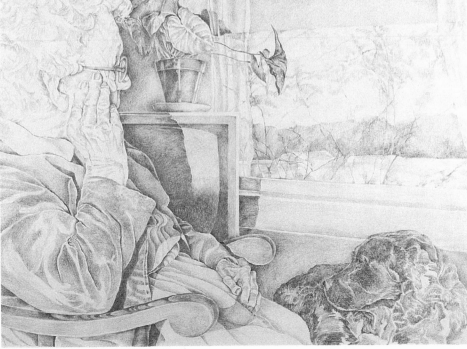

Gazing out the Window
Hazel would often look longingly out her window. Working on the pieces, my connection to her grew stronger.

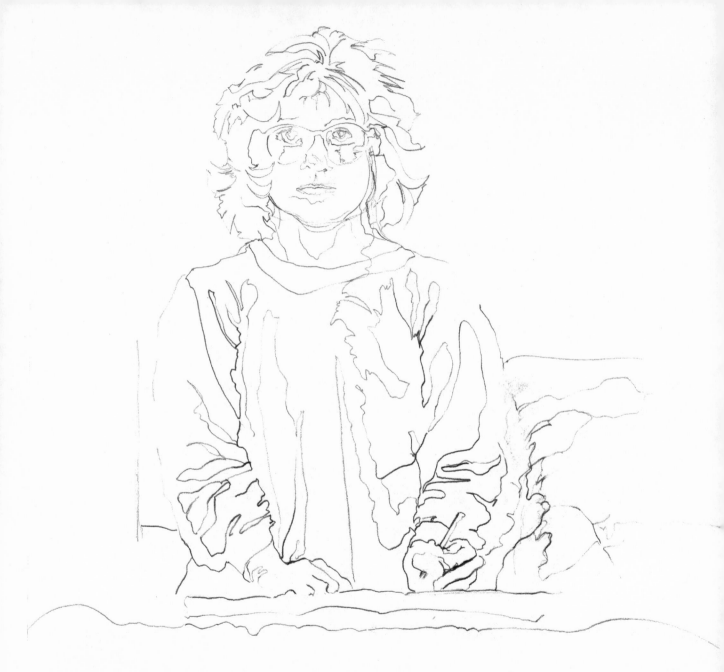

blind contour drawing

MATERIALS

Two to four relatively soft graphite
drawing pencils: HB, 4B or 6B

Large drawing pad,
approximately 18" × 26"
(46cm × 66cm)

Clipboard that fits
the drawing pad

No erasers yet—we
don't care what these
drawings look like!

Blind contour drawing is the act of sketching something or someone without looking at the paper. This may not seem like a remarkable task until you realize how much energy is expended staring into that paper. Drawing blind allows the hand and arm to become a tool of the eye. Once you understand this concept—that in order to draw realistically, you have to draw exactly what you see, and not what you think you see or know to be there—the mystery of drawing is unlocked.

Here is a series of blind contour exercises; use them as a means of overcoming your natural tendencies. I've discovered this method to be a great equalizer in my classes. People who come to the class with previous training are soon humbled, and those who come terrified of drawing loosen up and drop their guard. These exercises serve as a means of tossing everyone into the same pot.

blind contour

Complete these exercises by looking into a large mirror that you can face comfortably. It can be an even better experience if you find a partner.

Stare at your face in the mirror, or at your partner's face, and visualize how what you see will fit onto the page. Imagine that you are a small bug moving across the surface of the person to be drawn, or imagine the person you see as Mount Rushmore and you as a tiny traveler on its face. If you are a small form moving across a big form, you won't be hopping or jumping, so keep the pencil to the paper; don't lift it or use quick strokes. Blind contour drawing is a slow, meditative process; each exercise should take about twenty minutes.

Keep your eyes solely on the person or reflection you are drawing. I'll allow one look at the page if you're losing control or think you might run off the paper. Start the contour, moving across the surface of the subject's skin as though you were touching it. Move in from the outside edges of the face and body to include features. This exercise is a search for what is underneath the surface of the skin—a search for form—using your hand to extract information.

Parts of the contour line will be lighter or darker than others, depending on how hard you press. Control your pressure so you can use light and dark to your advantage. When you draw lighter areas such as cheekbones, lift up on the pencil. When drawing darker areas, press harder.

the **right** way

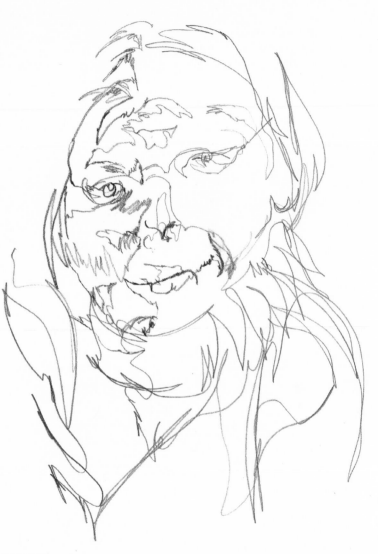

Draw Dimensionally

Blind contour drawings should show your search for three-dimensional features. The line should meander both in and out of the exterior. Use a large enough sheet of paper to include a lot of information.

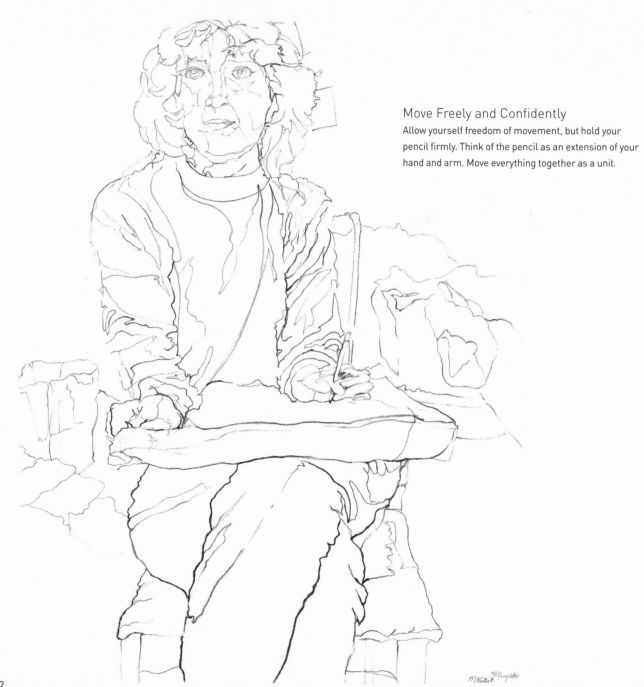

Move Freely and Confidently

Allow yourself freedom of movement, but hold your pencil firmly. Think of the pencil as an extension of your hand and arm. Move everything together as a unit.

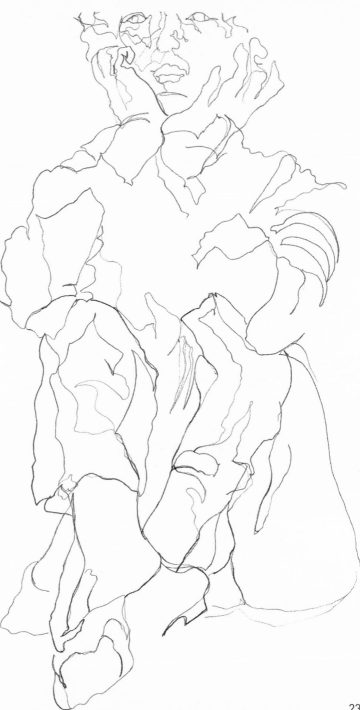

Focus on the Figure Itself

Look at your drawing. Does it demonstrate
that your eyes were locked onto the form
in front of you instead of the paper?

the **wrong** way

In these drawings, notice that the contour line reveals little about form because there is no variation of light and dark within the line. Too much attention is given to superficial surface details such as glasses, eyelashes and eyebrows. Keep trying until you feel your hand becoming an extension of your eyes. Use the whole page.

Uninformative Contour Line

If the contour line has no change in value (light or dark) or stays mainly on the outside of the shape, it will not be informative.

using your off-hand

EXERCISE

This one's pretty self-explanatory: right-handers, use your left. Leftie's, draw with your right. I don't know about you, but I am completely hopeless when it comes to using my off-hand. You may ask yourself why this crazy lady is making you do this, but I promise, once you start you'll see the wisdom, as these exercises begin to free you from your preconceived notions of drawing.

Many students feel more at ease with this exercise than with the normal assignments. They figure they've got nothing to lose, since they're going in with a handicap and are guaranteed something that looks funny no matter what.

Your Off-Hand Will Thank You
Have fun and be free! Draw at least three blind contour drawings with your off-hand.

switching the format

EXERCISE

What format have you been using? Those of you inclined to use a vertical format, turn the drawing pad to the horizontal. Those using a horizontal format, turn the pad so that it becomes vertical. This will change things dramatically, but keep visualizing the initial composition and squeezing the original dimensions into the new format.

Start at the bottom and work upward in a continuous contour, keeping pencil to paper. If by the time you have reached your subject's head, you have only two inches (51mm) of paper left, you must still try to squeeze the contour onto the page. Blind contour exercises are supposed to free us from normal expectations. Draw as "badly" and out of proportion as you like.

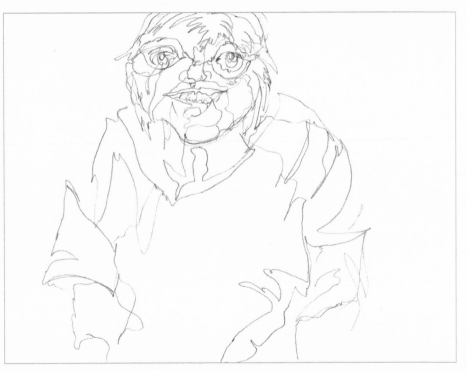

Take Advantage of This Opportunity!
Sometimes, our best work stems from new methods and their unplanned results.

inner contour drawing
EXERCISE

For this blind contour drawing, start at the top of the form and work only within the center of the body, staying away from any exterior contour that encloses or outlines it. For example, when drawing the eye, draw only the inside, not the outside, contours. Don't outline the face, but concentrate on the contours that lie within it. Keep this thought as you move downward on the subject.

Why would I ask you to complete a contour drawing that seems to describe so little of the subject? When we concentrate hard on outlining our subject, we miss the opportunity to describe its most important aspect—what lies within.

Turning Inward
This exercise forces you to focus on the interior of the form and refrain from pouring most of your energy into enclosing it.

Initially, you'll probably want to laugh uncomfortably while doing a blind contour drawing. But once immersed in these exercises, you'll most likely become quiet and meditative. There is truth to the theory that drawing exercises the right side of the brain. We don't often let ourselves work the "muscles" there so completely, so it's common to feel fatigued after a few contour drawings.

What does this all mean? Why is it so important to pay close attention to this stage of the process? Without an understanding of the value of blind contour drawing, the true nature of drawing can never be grasped. The blind contour offers an excellent opportunity for your personality to pour onto the page. Look at the completed exercises. What is truly unique about your drawing? Each of us has an individual way of expressing ourselves through this process. It's imperative to stop and analyze your contour sketches, paying attention to what is innate to your personality. What does your contour line look like? Eventually, you will be able to imbue your planned compositions with similar expressions of your personality.

discovering your
personality

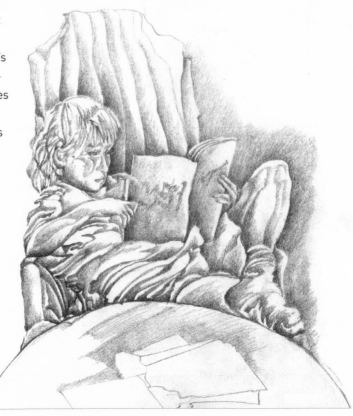

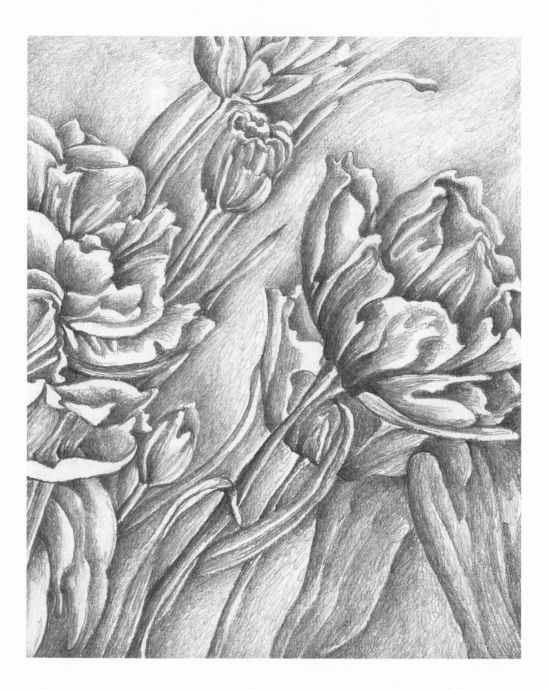

adding value to contour

MATERIALS

Two to four relatively soft graphite pencils: HB, 4B, or 6B

Desk light

Kneaded eraser

Clipboard that fits the drawing pad

Large drawing pad, approximately 18" × 26" (46cm × 66cm)

White cloth to be used as ground covering for the still life

Now that you have loosened

up and are beginning to understand the importance of drawing what you see (and not what you know to be there), let's talk about what contour is. Contour lines define form as opposed to shape. A shape is a two-dimensional figure, while form has depth.

Think of the contour line as the edge of the forms adjacent to it. What we see around us in our three-dimensional world cannot be revealed only in a few grays, blacks and whites, but through a range of many values. It is important for the contour line to reflect this.

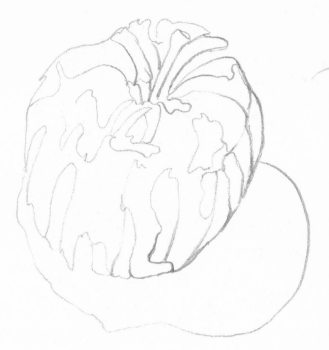

lines versus **contours**

What is the difference between a line drawing and a contour drawing? A line is generally a continuous pathway from point A to point B; it may not describe anything more than that. A contour line is different. Contour lines help define the form of an object, its position in three-dimensional space. Contour lines give depth to a drawing.

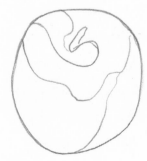

Line Drawing
Here you can see the shape of the subject, but it looks flat and two-dimensional. The form of the subject is not captured.

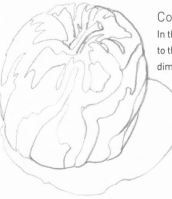

Contour Drawing
In this drawing, there is depth to the subject and a three-dimensional form emerges.

Line becomes contour when it varies in value to describe form. What is value? Basically, value is the relative lightness or darkness of a shape. This is a crucial concept in drawing: an object is defined in space and made three-dimensional as much by the light and shadows surrounding it as it is by the lines that define it.

Sound complicated? It's a tricky concept, but once you've mastered the techniques associated with it, you can make any drawing leap off the page. All forms are composed of different planes or contours, whose outlines you can draw. Think of drawing a face; you use lines to show the eyes, nose and mouth. However, when you're trying to make a face look three-dimensional, you have to indicate the roundness of the features and their protrusion into space by using lights and darks. The lines aren't enough.

using **value** to describe **form**

Minding the Light Source

When drawing anything—be it from a controlled still life, a photograph or the real world—it is important to understand where the light in the scene is coming from. Every form has a light and a dark side, and their locations depend on where the light source is. The values in your drawing will be correct only if they're all consistent with the light source.

aspects of
value

Value describes the lightness or darkness of form. For the purposes of this text, I will use a scale from zero to ten; zero as white and ten as black. When describing form, it is fundamental to understand that the value within the contour changes. Remember, we are not talking about color here, but the lightness and darkness of forms; their blacks, whites and grays.

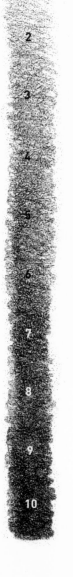

Value Scale
Try one yourself, striving for a smooth transition from white to black. Squint your eyes to fill in the gaps between values. You may have to do this several times to achieve success.

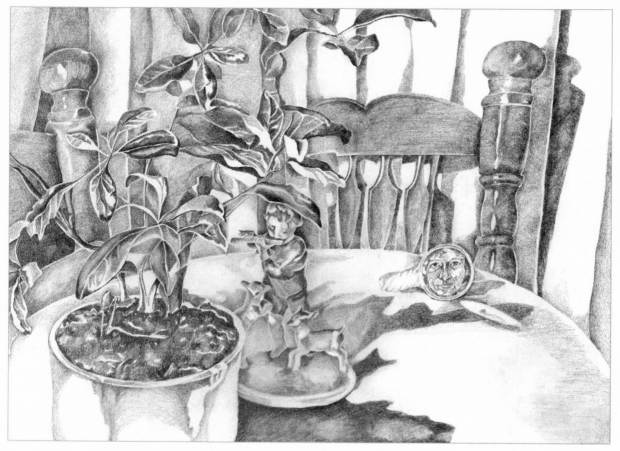

Finished Drawing

Notice how the contour lines turn to follow the form. The value
range on the leaves reveal much about the plant's physiology.

composition
basics

Let's take a preliminary look at how contour drawings aid composition (which will be discussed in greater detail later). The contour line will be the framework for your drawings, so the information contained within it needs to be considered carefully. Imagine yourself drawing flowers within a garden. What is it about them that you want to say? Where is your emphasis? Where is the light source? What components of the composition are similar? How are you going to position the forms on the page? How do they relate to the surrounding space? These are a few of the preliminary questions to ask yourself as you begin a contour drawing.

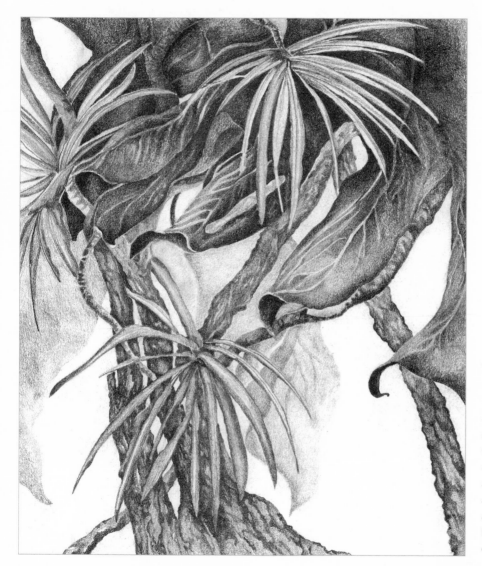

What Makes a Composition?

Notice the similarities in the contours of the flowers. Take advantage of these similarities to create a pattern of repeating elements that will encourage the viewer's eye to move around the composition. Notice also how the value contrasts between the flowers and foliage emphasize negative space.

composing using contour
EXERCISE

To begin learning to compose with contour, your first assignment will be a simple one: Create a series of three blind contour drawings with a connecting "story line" and similar compositional elements. Each drawing should be 8½" × 11" (22cm × 28cm). Remember, you should work large when doing blind contour drawings. Create a border on your paper about 1-inch (25mm) on the top and sides and 1½-inch (38mm) on the bottom. Use only contour drawing and draw about 80 to 90-percent blind (look at the paper only a few times).

EXTRAS

Three green or yellow peppers

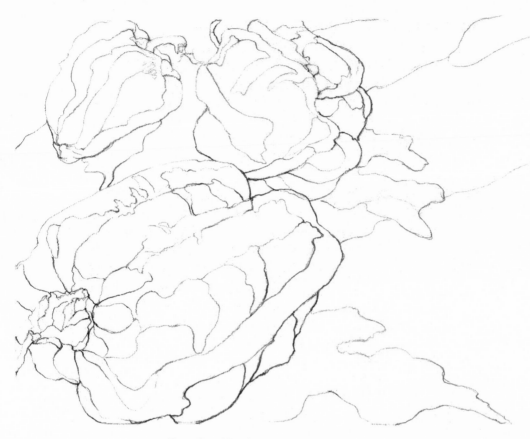

Drawing No. 1

Place the peppers on the white cloth, darken the room and direct the light onto the peppers. From your vantage point, the peppers should overlap.

Before starting, consider what the contour drawing should depict. Because the forms overlap, you will need to carefully distinguish between the foreground and background. To establish the foreground and make it more prominent than the background, the contour lines of the subjects in the front should be darker in value than those in the back. The peppers in front will also appear larger.

The contour lines of the shadows will not have the clarity or darkness of the contours of the peppers, since the shadows are just a reflection of the main subject. Use the cast shadows to anchor the peppers to the table.

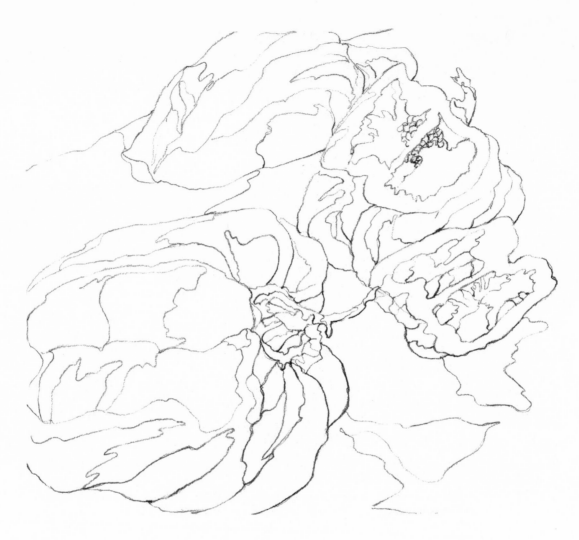

Drawing No. 2

Cut one of the peppers in half. Begin to pull the forms away from each other. As the peppers are cut and separated, another story emerges: one of a parent to a child, a whole to its parts.

Drawing No. 3

Cut another pepper in half, then cut and pull another into pieces. Strew the components away from the center of the still life.

The third scene in the series takes the story line further. As the whole peppers are dissected, a sense of movement develops. The parts move away from the whole and the insides spill out onto the ground.

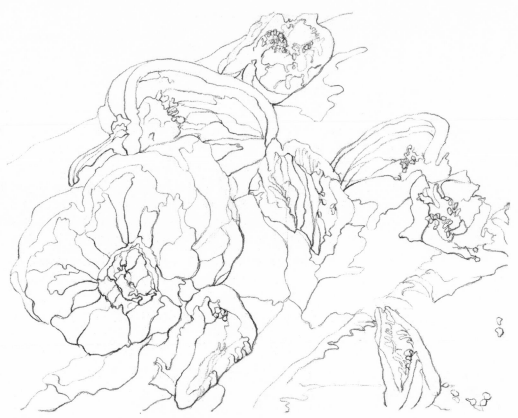

IN SUMMARY

By using the same images throughout these three drawings, we have established a story line. It consists of whole forms being dissected into parts, which then move away from the whole and become even more fragmented. Still lifes are your most controlled drawing subjects, so you can use them to create an interesting narrative. By directing the light and giving careful thought to the placement of the forms, highlights and shadows, as well as their relationships to one another, you can create the illusion of three dimensions.

the art of
gradation

Values change and repeat throughout a composition. Employ *gradation*, the gradual transition from one value to another—lighter or darker—to show where the light source is coming from and to develop rounded, dimensional forms.

These pages contain examples of careful observation of the complicated forms within the contours of a thumb. Try not to let this study overwhelm you. If it's easier for you to enlarge the subject even further, feel free to do so.

The gradations of value within the drawing follow the direction of the light (from the left). Notice that the values generally are lighter on the side nearest the light source, but that some areas on that side are shaded because the light is being blocked by other forms and folds in the skin. As you work, remember that the direction of the pencil strokes needs to follow the contours of the form.

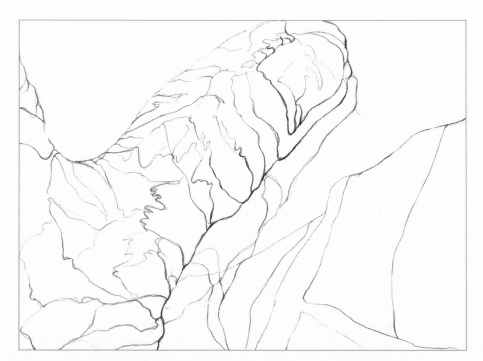

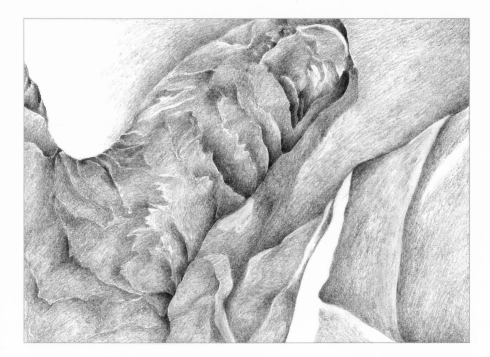

INCORRECT GRADATIONS

Contour drawing with gradations that don't provide enough contrast to establish form.

Contour drawing with too much value contrast along the contour line. More gradation is needed.

still life with different light directions

You'll find that I seldom have you complete just one drawing for an exercise. Doing a series of drawings will help you become accustomed to telling a story through composition, and also will help you hone your skills. This is a two-drawing series.

You may add to these assignments by changing the story line. Varying the placement of the subjects while keeping the light source constant will allow you to explore new compositional possibilities. Try moving objects away from the grouping, fragmenting them or tipping them over onto their sides. Explore the relationships between contrasting shapes, sizes and positions.

Once your emotion is poured into the blind contour drawing, you are free to add value to make the lines come alive. Take note of how the contour drawings on page 46–47 reveal the placement of the value gradations and provide a template for the final compositions. In fact, the gradations are just an extension of the valuable information found within the contour line.

Learning to draw well means mastering the variations of value within an object, and gradation exercises help you understand value. Spending time conquering these concepts now will smooth the path for your journey of self-discovery through drawing.

Remember, when you are on site and the light seems to emanate from everywhere, you should choose a direction for it to come from. This will establish consistency, rhythm and repetition within your work. Lose control of the light, and you lose control of the composition.

EXTRAS

Two whole garlic bulbs

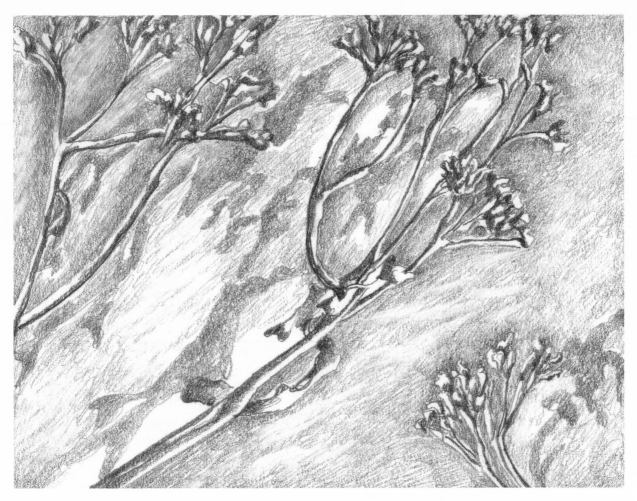

You Control the Light

See how confusing it is when the light source is inconsistent?

Which plants belong with which shadows?

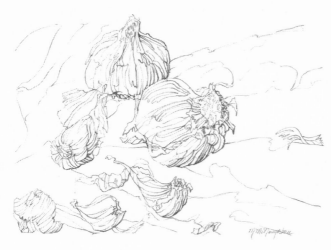

Contour and Full-Value Drawings With Light Source at Left

On the white cloth, arrange one garlic bulb upright and one on its side with a few of the cloves separated from the whole and strewn about. This creates a relationship of parts to a whole. Place the light source so that it casts light across the subject material from the left. Carefully consider how the composition will fit onto the page; don't be afraid to enlarge forms and let them break out of the borders. Anchor the objects with cast shadows.

Complete the contour drawing, keeping your eye on the forms and moving in and out of the exterior line. Carefully review the contour drawing. If you never saw the garlic again, would you have enough information to complete the supporting value gradations? If so, add the gradations, moving from light to dark and left to right.

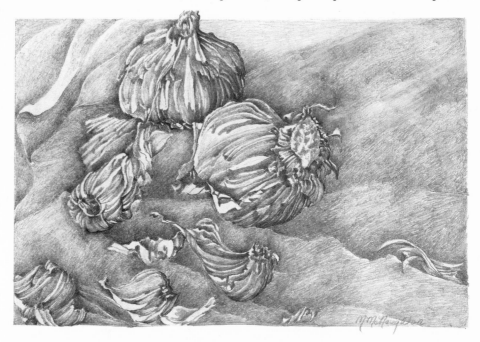

Light Source at Right

Keeping the composition exactly the same, move the light source so that it casts light across the subjects from the right. Do another contour drawing that indicates the different gradations and positions of the cast shadows. Take liberties with the placement of the light source to achieve unusual effects within the shadow shapes.

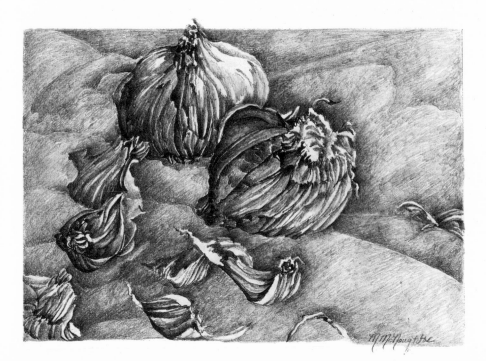

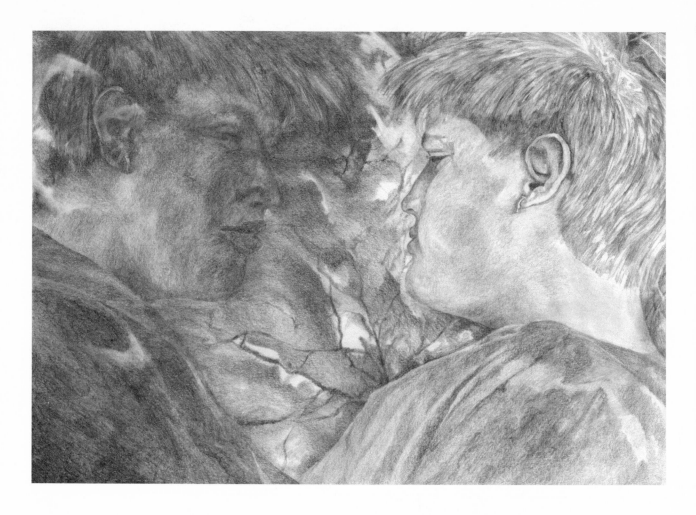

capturing texture

MATERIALS

Two to three fine-tipped black
ink drawing pens

One medium-tipped black ink
drawing pen

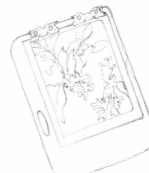

Large drawing pad,
approximately 18" × 26"
(46cm × 66cm)

Clipboard that fits the
drawing pad

Texture is merely a term for the irregularities in the surface of an object. It is definitely an important component of realism. But before I introduce some techniques for capturing it, let me warn you: There is a danger involved in depicting texture when we overestimate how much it tells us about the form. In fact, texture tells us very little about the three-dimensional characteristics of a subject. It merely indicates the nature of the surface.

stippling
EXERCISE

Stippling is the process of laying down black dots or marks to achieve value gradation.

When using pens for stippling, I like to use a variety of thickness in the tips: fine to medium. You can achieve darker values by pushing harder or laying the marks closer together.

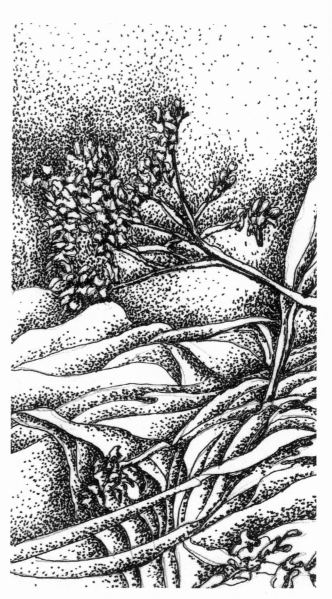

Stippled Organic Forms
Stippling achieves value gradations in a controlled manner like no other technique. Just one more dot here or there to reach perfection!

the right way

Choose a small piece of paper and create a gradation, moving from white to black by applying a series of dots. Begin dotting sparsely, then apply more marks closer together as the value darkens.

Using Stippling to Create Gradation

Try to get a smooth transition, incorporating all the values in the scale from one to ten. (See page 34 for a value scale.) Squint your eyes to determine if there are any jumps or ridges in the value progression.

the**wrong** way

These incorrect examples demonstrate that the contour line must be reinforced by value gradations or the contour will disappear. The density of the stipples should be different on either side of the line so that the contour line remains distinct.

Stippling is meant to simulate the value gradations that occur when light strikes an object. Sometimes though, it may also imply a granular, pebble-like texture.

DON'T MAKE PATTERNS!

I had a gentleman in an evening class who wanted to learn how to draw in order to break out of his routine as an accountant. And he was doing just fine until he discovered stippling. Before I knew it, he had two pens going simultaneously, dotting in a methodical manner creating a very visible pattern. Stippling is every obsessive person's dream come true. I don't want to belittle this technique, however, because it allows us to depict and control gradations clearly and well. Just be careful to use stippling to enhance your art, and not just to create orderly patterns of dots.

Use Gradation to Reinforce Contour

Placing too many stipples close to the line will result in a value that is too dark, creating a shadowy trough along the contour line. Be sure the density of your dots matches the value you are trying to achieve. Gradual transitions from one value to another will help the viewer's eye move smoothly through the drawing.

Use Density to Maintain Contours

This sketch shows how stippling that is inconsistent with the light source can confuse the viewer. When stippling occurs on both sides of the contour, its density should be greater on one side or the other to preserve the contours of the form. Also avoid placing stipples on the contour line itself; otherwise the object will look fuzzy or furry.

Be Confident

Timidity with stippling will affect the impact of the drawing. Support the line with appropriate values rather than making a weak attempt at some scattered stipples that do nothing to describe the form.

hatching
EXERCISE

Hatching is a means of creating value gradations with parallel (or nearly parallel) strokes called *hatches*. As a technique, hatching will describe certain textural surfaces more readily than others. Hatching is ideally suited for rendering fur, bristles and hair.

HATCHING

Hatch marks should always follow the contours of the form underlying the texture they are being used to create.

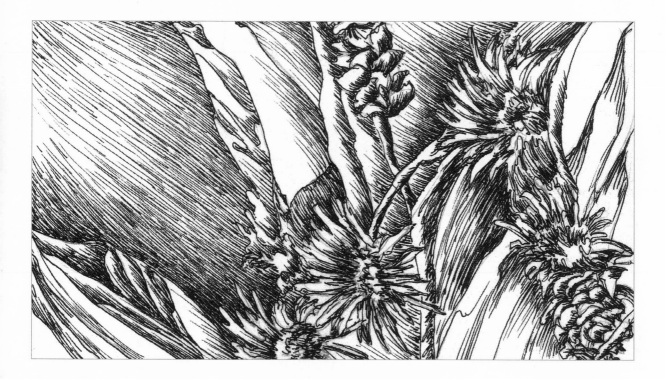

Hatching Organic Forms

The hatches should be farther apart in areas of lighter value, and come closer together as the value darkens.

the right way

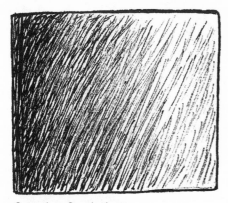

Creating Gradation
Hatch lines are straight to support
the rigid lines of the square.

Supporting the Underlying Form
Remember, hatching can be used to create
great surface texture, but it always needs to
follow the contours of the form underneath.
 See how the hatches curve and bend to
support (or follow) the rounded form.

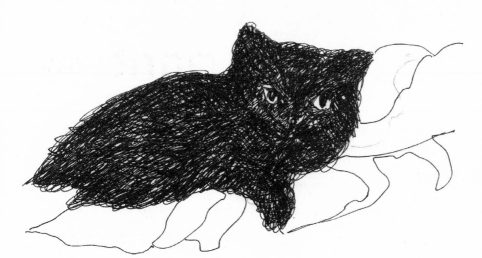

The Blob

When a form, such as this cat, lacks definition, it is usually because the shading doesn't describe the body under the fur. This drawing demonstrates little understanding of the use of hatching to portray texture or to support the contours of the form.

the **wrong** way

Ignoring the Underlying Form

Here the hatching does not follow the curved contour, wasting their potential for being descriptive.

vary your **strokes**

Students often make the mistake of thinking of the hatch marks as long lines that stretch from one end of the object to the other. Instead, these marks can be either short or long, depending on the texture you're creating.

Short Strokes
Short strokes can be used to portray fur or texture.

Long Strokes
Long strokes imply loose, flowing shapes.

Variation is Organic

Here, the long strokes imply movement for a dramatic background,
while the short strokes are better suited for the texture and form.

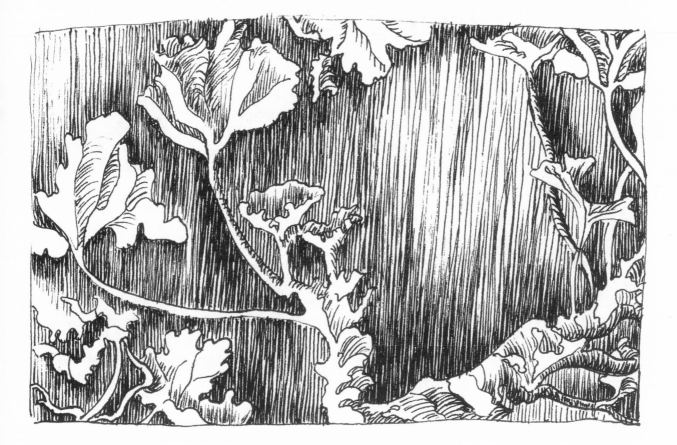

crosshatching
EXERCISE

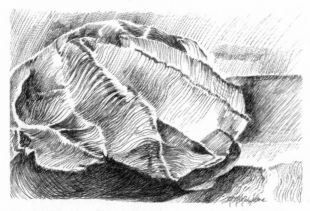

1930s Flapper Hat
Hatching defines contours; crosshatching gives added depth and texture to a drawing. Be careful not to lay down your crosshatches with a heavy hand or you could dramatically change things fast.

Crosshatching is the technique of adding value to hatch marks by laying parallel strokes counter to the existing grid. Basically, it's hatching in two different directions. This technique should be used sparingly, as value will be added very quickly and can easily take over the drawing.

For this exercise, draw two or three organic forms in a small area. Try to look for objects that have characteristics, such as veins or textural lines, that will be enhanced by hatching. Pumpkins make good subjects, as do flowers.

Start with one informative contour line. After the contour drawing is done and the outline of the object has been established, create gradations by hatching and crosshatching.

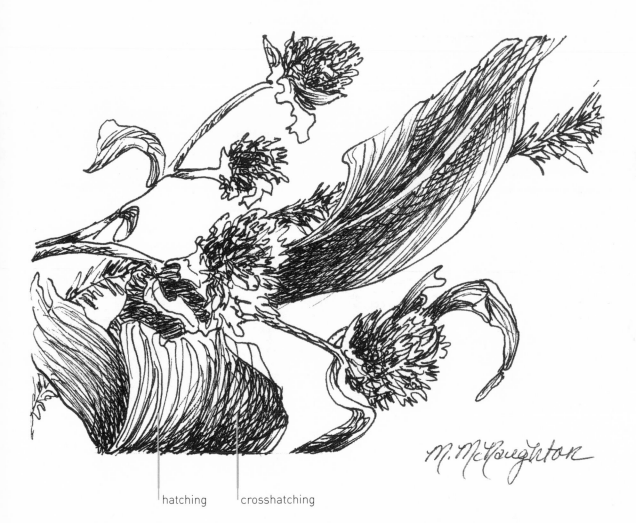

hatching crosshatching

textural handwriting
EXERCISE

Imagine that you have been very bad and the teacher has made you stay after school to write your name over and over on the blackboard. Write your name freely and create a block of this writing, moving from left to right. Leave little space between the lines and begin to look up from the page as you write. Experience what the act of writing your name feels like—have fun with it.

Let your writing become more and more abstract. Move away from literal text and begin to scribble. Finally, create a gradation based upon this scribble. Some of you will have an angular, jutting script, some a more curved approach. That's the best thing about this technique—the results are as unique as each personality.

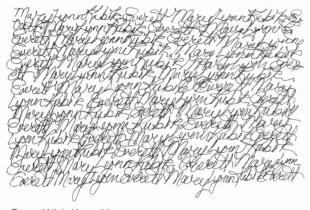

Start With Your Name...
Write your name over and over, as quickly as you can. (This was my name before I got married—girls, you know you did this!)

...and Let It Become Abstract
Look up from the paper and let your name become a scribble. Lose the literal meaning and just have fun with it.

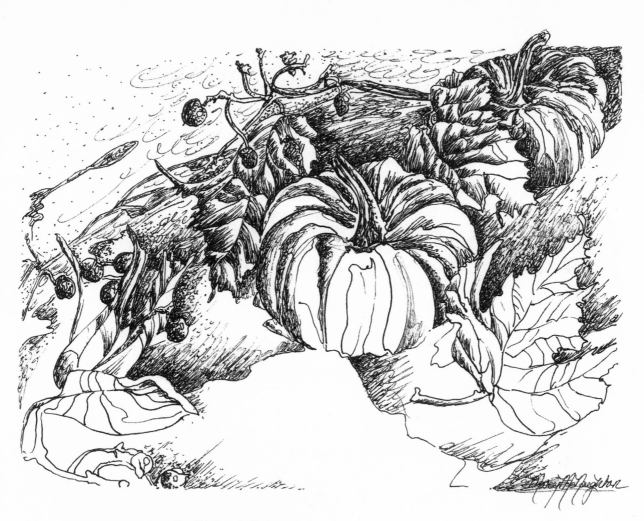

Scribbling in Values

Use your trademark "handwriting" scribbles to support a well-developed contour drawing. It's a fast, direct technique—and fun!

combining textural techniques

Before you begin drawing, cut your paper to about 8" × 10" (20cm x 25cm). Create borders ¾-inch (19mm) from the top and sides and ½-inch (13mm) from the bottom. Complete three ink contour drawings of a still life on drawing paper using a pen, keeping the placement of the subject material the same. However, experiment with using different texturing techniques, alone and together, to create realistic texture.

EXTRAS

Still-life materials such as hard-shell nuts, gourds, pumpkins, fruit or vegetables, leaves, and a branch or two

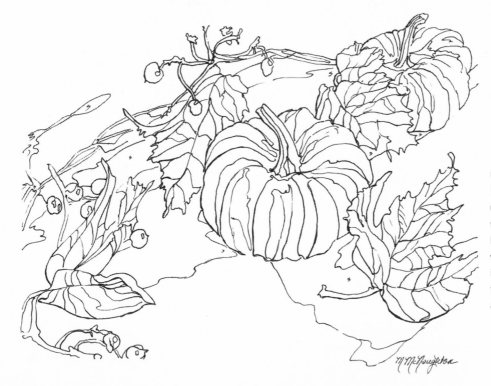

Contour Drawing of a Harvest Still Life

Contour drawings of organic forms should be free flowing (I have indicated shadow areas with a small s). The line varies in value to reveal depth and the location of the light source, among other things.

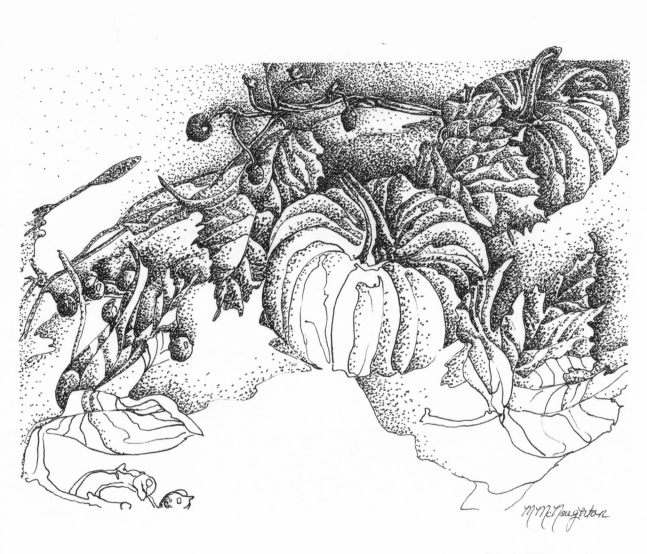

Stippled Harvest Scene
Stippling provides a stable, even
gradation of values.

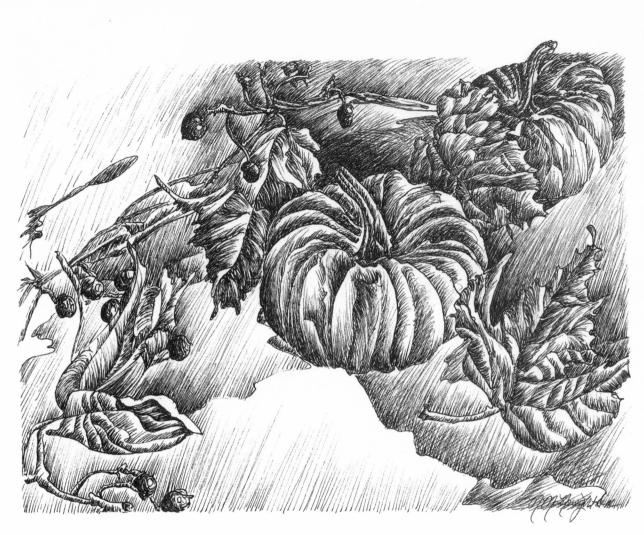

Hatched Harvest Scene

The hatch marks imply movement
to render a more fluid still life.

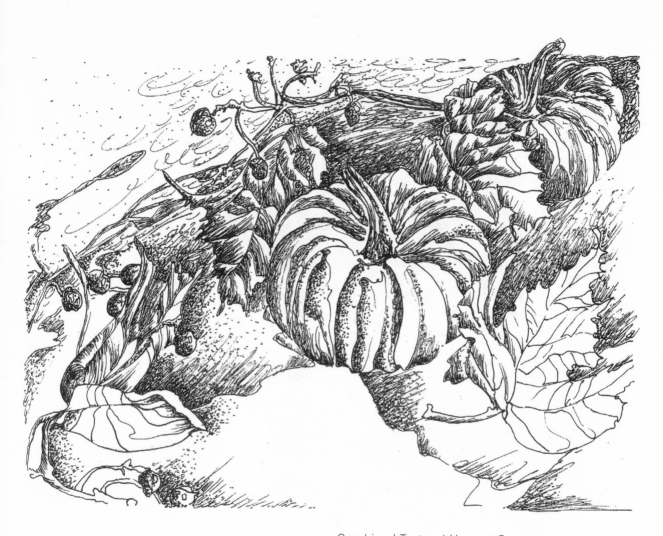

Combined Textural Harvest Scene

All together now! Remember to apply these different techniques judiciously around the composition. Think of each element as a possible grouping of textural effects.

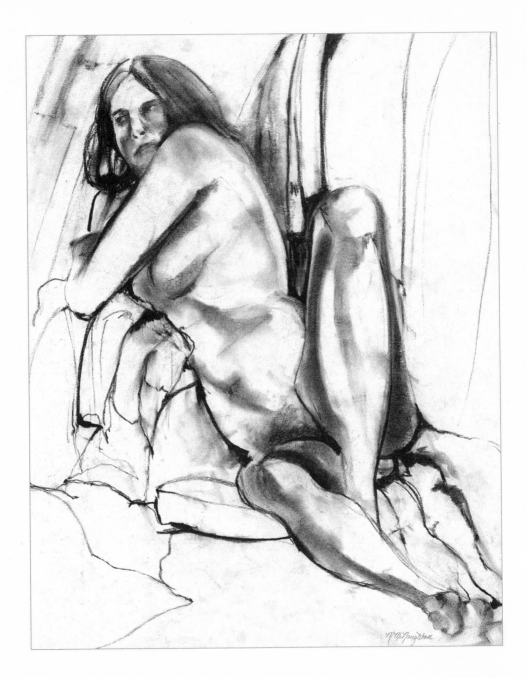

drawing ourselves

Kneaded eraser

Two to four relatively soft graphite pencils: HB, 4B, or 6B

Two to three fine-tipped black ink drawing pens

Two to three sticks compressed charcoal

Large drawing pad, approximately 18" × 26" (46cm × 66cm)

Clipboard that fits the drawing pad

What is it about the naked human body that causes most of my students to completely close down and forget

all their drawing basics? To be fair, the body is one of the most challenging subjects to capture accurately. Because we know it so well, we tend to make false assumptions about its proportions. And we may concentrate so hard on the proportions that we forget other fundamentals, such as keeping a consistent light source.

Whatever else I teach you about this subject matter, I must stress the importance of getting your face out of your drawing pad and concentrating on your subject. You must connect with the form in front of you. Therefore, I will introduce a variety of exercises that force you to do so.

foreshortening

Foreshortening is the technique of distorting the size of objects or parts of objects in order to show distance and depth. When you look at a model straight on, some parts of the body will appear compressed or even missing; it's an effect of perspective. Yet you must draw what you see, not what you know. If you can't see it, forget that the upper arm is there—even though you know it is—and draw only the shapes that are visible.

In the two examples on these pages, the forms in the foreground, such as the feet, seem to jump right at the viewer because they are so much larger than the forms in the background, such as the head and shoulders. Certain parts of the body seem to be missing because they are removed from our line of vision, so they need to be left out of the drawing if it is to look realistic.

Right Off the Page
The greatly enlarged legs and feet
seem to jump out at us.

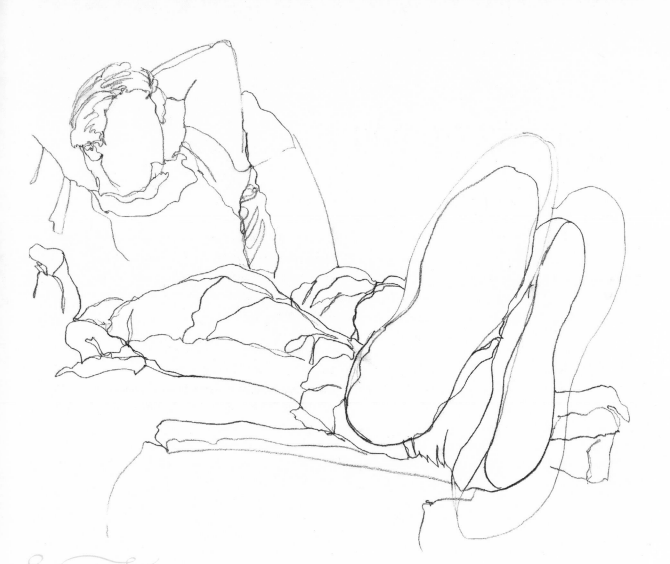

WORKING WITH LIVE MODELS

If you follow my instructions and pay attention to the examples, you should be drawing proficiently by the end of this book. I highly recommend that you take a class in order to work with a live nude model. College art departments often schedule modeling sessions that are open to the public for a fee. At the very least, convince a close friend or family member to pose for these exercises in a bathing suit. Practice is really the only way to improve figure drawing.

Like an Accordion

From our vantage point, the body appears compressed, especially in the legs. The gigantic feet nearly jut out of the drawing.

gesture drawing
EXERCISE

Gesture drawing conveys the essence of movement. It is a quick summation of the muscular composition of the human body; a fast, loose and continuous sketch meant to capture the essence of the subject rather than the details. Because of the spontaneous nature of the process, your hand should move as an extension of both the arm and the body.

Keep your eyes on your model the entire time, and set a timer for thirty seconds. It's best to use charcoal, pen or pencil with a drawing pad, as these allow you to go quickly and smoothly. If you're using charcoal, it should be a stick version that is a 1, 2 or 3 in hardness. Hold the drawing instrument so that it is an extension of your entire body. Try to capture the subject in thirty seconds.

Of course, with only thirty seconds, this sketch is not going to have the qualities of a developed drawing. It will be a fast summation with very loose lines. Do not focus on any facial details. Move in and out of the form—resist the temptation to stay on exterior lines.

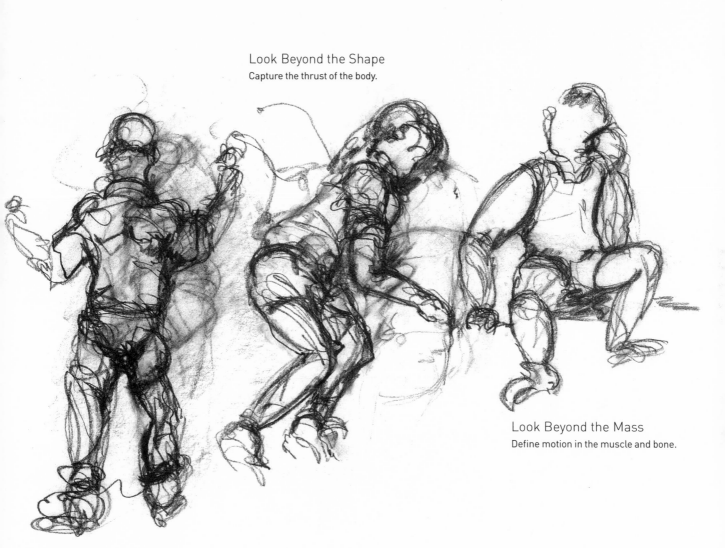

Look Beyond the Shape
Capture the thrust of the body.

Look Beyond the Mass
Define motion in the muscle and bone.

Look Beyond the Skin
Gesture drawing portrays movement
as the body leans and twists.

gestures in transition
EXERCISE

This will be a sequence on motion. Ask the model to hold three poses that convey a continuation of movement for ten seconds each, while you try to capture the entire form of each pose on the page in those ten seconds. These gesture drawings will be highly primitive in quality. The goal is to get the entire form on the page.

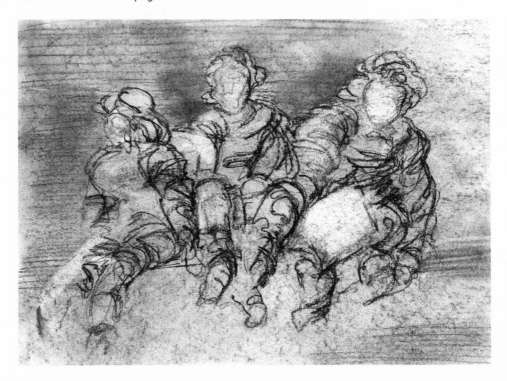

BLIND GESTURE STUDIES: INNER CONTOUR

Give yourself five minutes for each of these exercises, drawing 100-percent blind. Slow down, place your eyes on the model, and draw as if you were touching or feeling the form. The intent is to explore what lies underneath the skin in terms of bone and muscle. Start near the top of the face and move down the body. When something appears darker, dig in with the pencil; when lighter, lift up. Keep your eyes on the model and do not look at the paper at all.

While you move across the form, refrain from depicting the contours that enclose or sum up portions of the body. Convey only those contours that lie inside the outlines. This is awkward to do. We are conditioned to enclose forms, so it is these outer lines that seem the most important. But the reality is that inner contours are the most descriptive of the human form.

BLIND GESTURE STUDIES: ALL CONTOURS

Repeat the last exercise, but this time portray all of the contours, inner and outer. Draw 100-percent blind, searching for form as if feeling it. Again, limit yourself to five minutes.

If you find that your head is becoming buried in the drawing pad, force yourself back to the model. Repeat these studies to force yourself to focus on the model, not the paper.

Remember Value

As you're drawing quickly, remember to include different values to help you capture the essence of motion. Even if you're doing a five minute exercise, try to capture a sense of immediacy by getting that gesture or contour on the paper within two minutes. Five minutes is not long at all. The last three minutes can be used to refine and add some value gradations.

sustained studies

MODEL IN A SETTING

These exercises involve more sustained studies and should be timed to last thirty to forty-five minutes. For these, the model should recline or sit. Darken the room and focus a light on the model. Use pillows, draped fabric pinned to a backdrop, or a soft divan or cushion to place your model in a distinct setting. Plants can also add to the composition. Be creative with this setting, but keep it relatively simple. Your main focus is still the human form.

These studies will help you begin to see the human form in space. The figure should not float on the page, but should be more defined by its setting. Explore relationships among the contrasting elements and look for similarities in form between the body and setting.

Use the Setting for Support

As the model leans and twists, the supporting elements of the chair, cushions and drapery anchor her form, giving stability and counterbalancing the tension within the body.

PLACES OF THE BODY

Set the timer for forty minutes. Again, the model should strike a reclining pose. For this session, create three to four frames, each about 3" × 5" (8cm × 13cm) or 5" × 7" (13cm × 18cm), in a sequence of small compositions on one page. Use each frame to explore a different portion of the body. Each section should take approximately ten to fifteen minutes. Move randomly around the form and creatively select areas. Be sure to consider the space around body parts.

These small compositions should be considered as close inspections or details of parts of the same body. When you're finished, step back and examine how the compositions work as a series.

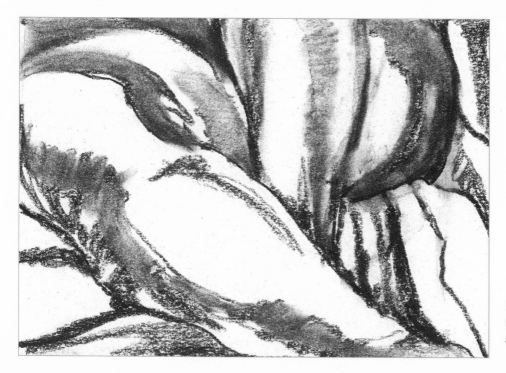

Enlarge Forms
Enlarge the form and creatively allow forms to free themselves.

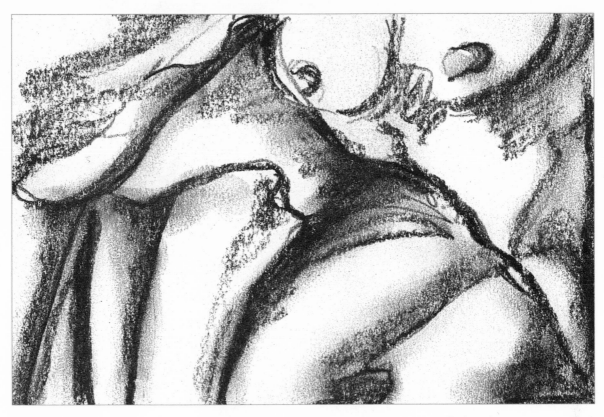

Balancing
Examine how portions of the body
balance each other.

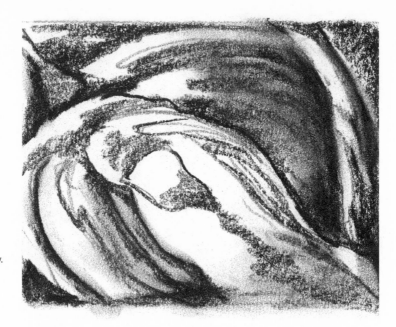

Negative Space
Use the negative space creatively.

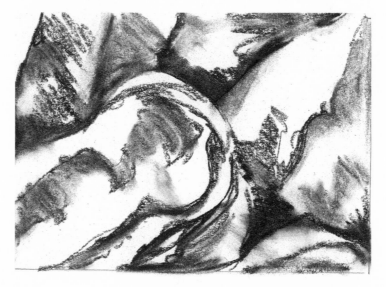

Counterbalance
Counterbalance long extended forms with curved compact areas.

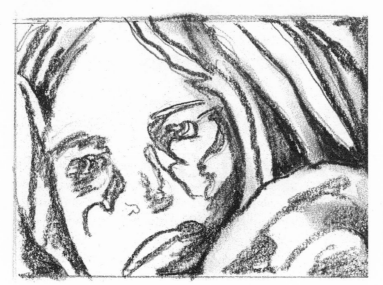

Light Source
Remember to choose a location for your light source. Make it work for your story.

A Close Examination
Examine forms and shapes closely.

summary of
figure drawing

All of the exercises on the preceding pages can be repeated as often as needed to develop proficiency with drawing the human form. You may refer to books giving more particular information about body proportions; however, I have found that by keeping the eye on the model and working approximately 90-percent blind, one does not have to think so hard about the dimensions of the bodyparts. Instead, you will be drawing what you see, allowing the hand to become an extension of the eye. In this manner, the formidable task of drawing the human body will become less daunting. As with anything else, the more you practice, the better you will draw.

For most of you, the human body will present the greatest challenges as a subject. Our close association to ourselves makes it difficult to detach and draw freely. When working from a model, lock your eyes on the subject and try not to think too much; just see. Remember, you are not completing a portrait. We do not care what the model looks like. Choose a definite light source even if you see light coming from different directions. You are in charge and you determine the outcome. You choose what you want to say with your drawing.

The model may be posing in a complex setting of drapery, plants and pillows. Are you examining how the setting balances the body? Are you zooming in on details? Are you exploring the contrast of human flesh to the textural elements in the setting? Are you revealing how the light travels across the cheek and breastbone?

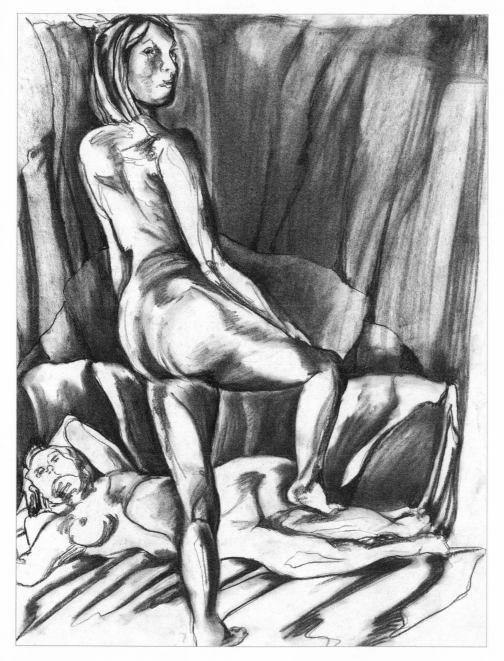

Endless Choices

The following drawings each resulted from a series of choices. The human body offers much, so try not to say it all at once.

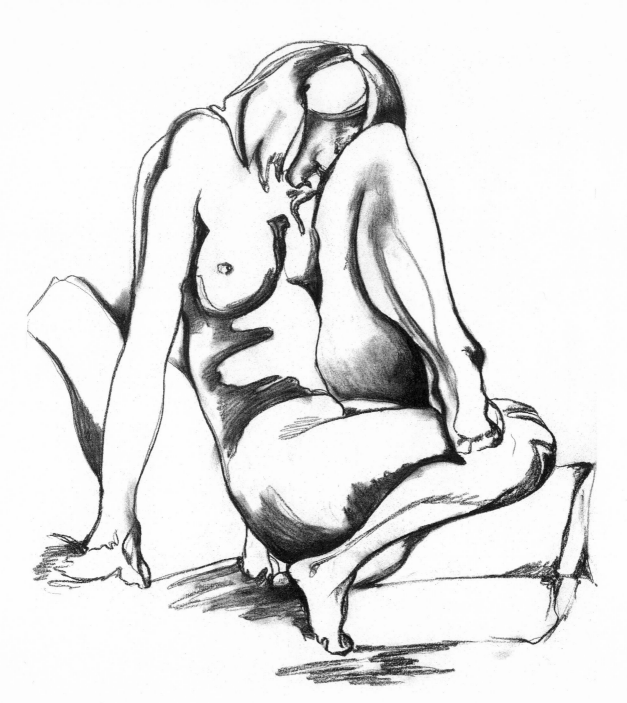

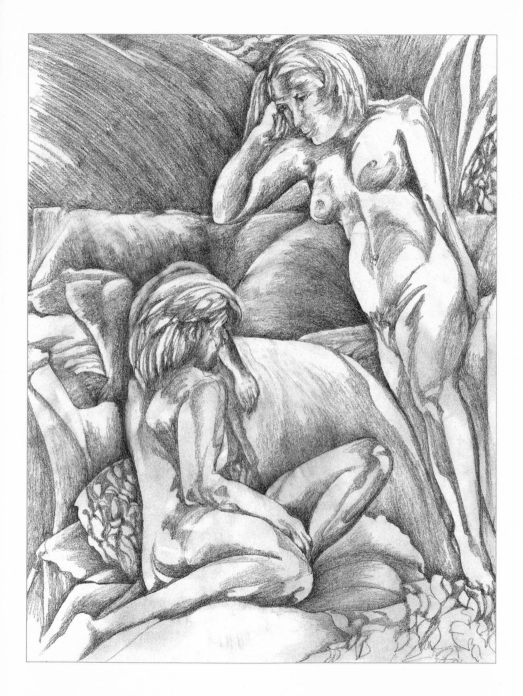

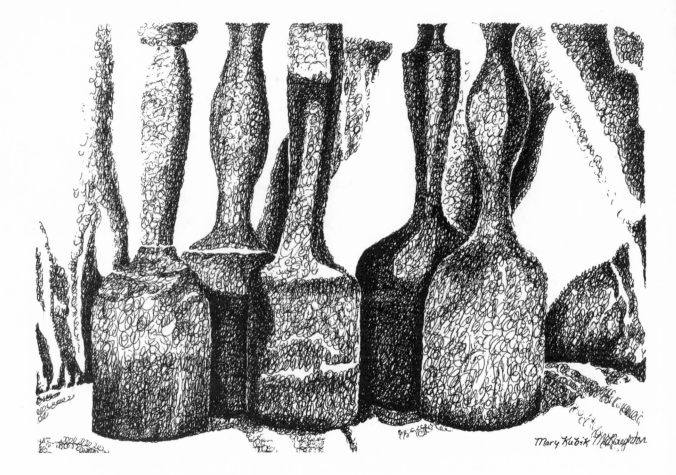

Mary Kubik M(illegible)

composing your drawings

Two to four relatively soft graphite pencils: HB, 4B, or 6B

One medium-tipped black ink drawing pen; two to three fine-tipped black ink drawing pens

Scissors

Glue Stick

Large drawing pad, approximately 18" × 26" (46cm × 66cm)

Clipboard that fits the drawing pad

Composition is one of the fundamentals of drawing, just as important as contour, gradation, medium and technique. I've waited until now to explain this concept because deciding what to put in your drawing, and where, can seem daunting, and might have been overwhelming.

Where does composition fit into the development of a drawing? When do you start to think about it? I am a firm believer that composition cannot be separated from the emotional and visual aspects of drawing. Therefore, even when starting a drawing with a blind contour sketch, you should consider the elements of composition before laying medium to paper. The important thing to remember about composition is that you want to plan a piece that shows your individuality and creativity. You can make unique, exciting choices about subjects and the placement of forms to create compelling works.

drawing
friendly

Objects that don't dictate too much—that is, objects that we aren't intimately familiar with, objects that we can't draw from a mental picture—are those that are considered friendly. These are the forms that are less regular and less perfect and which will be less familiar to your viewers. Remember, the viewer of our work rarely cares how perfectly the subject material is depicted. A connection to the subject is just as powerful as technical mastery.

Often, drawings such as this cat reveal nothing interesting about their three-dimensional nature—it's the whimsical character of the face that becomes the focal point. The furry surface texture is also prominent. Often, these types of subjects make very successful drawings. The viewer will have a reaction to these elements that's just as potent as seeing a technically perfect, anatomical drawing of a cat.

A Subject We Can Relate To
This doesn't look exactly like a cat anatomically, but since viewers relate to the subject, they will fill in the details and have an emotional reaction, making it a pleasing drawing.

Let's discuss the qualities of this radio. First, it is black. Because the whole object is at the dark end of the value scale, it becomes difficult to see any light areas. In order to depict this form well, one would need to ignore reality and imagine a more complete range of values within the black. Already there is one hurdle to overcome.

Second, the radio is hard and square and it will say to you, "I am hard and square. You must draw me the way I am." This leaves you, as the artist, with few options. Third, it is something we know well, with unchanging, exact features that leave little room for interpretation. It's helpful to avoid choosing dictatorial—unfriendly—forms for your subjects.

drawing
unfriendly

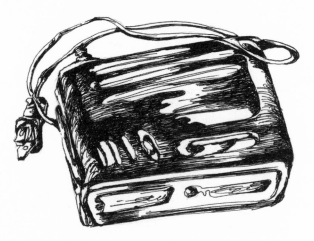

A Subject That Is Too Defined
As well as being black (which makes it hard to use values to create three-dimensionality), this radio is so familiar and so defined that it's not as open to your artistic interpretation as other subjects might be. Less fun to draw!

making a subject
your own

Another object I see often as a subject in students' drawings is a pop can—artists tend to pick subjects they have on hand. Well, a more unfriendly form for drawing would be hard to find. It is hard-edged, metal, symmetrical, and most people think its logo is the most important characteristic. Because of the logo's dominance, the student forgets to incorporate the lettering into the nature of the form or the gradation of its values. The brand of the drink should not be of any importance to the viewer unless you are designing an advertisement.

How can we make a pop can somewhat (and I do mean somewhat) drawing-friendly? Such a form must be made as easy to individually interpret as possible. Make it your own. Try twisting it, ripping it, squashing it—anything to make the object as irregular as possible. Cast a light on it from an unexpected angle. If you really want to include the logo, give only a hint, incorporating it into the entire form.

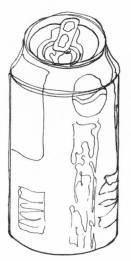

The Unfriendly Can
This can is cylindrical, symmetrical and downright hard to draw.

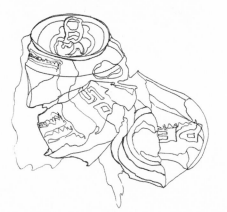

Making it Your Own
When the can is altered by twisting, ripping and crushing, it becomes much easier—and much more fun—to draw.

Organic Subjects

Still lifes often involve edible organic objects such as fruit or vegetables. Some of these are more drawing-friendly than others. A banana is not that much fun to draw because of its regular, long, cylindrical shape.

Making a form more drawing-friendly involves decision-making on two levels. The first is choosing subject material that has a fluid, irregular form and is generally light in value. The second is determining how more difficult forms can be manipulated to reveal a story.

Peeling Off the Unfriendly

How can we make the banana easier to describe? Peel it, break off pieces, manipulate it until you see something in it you want to draw. Now, you are telling a story.

Objects are more fun to draw and easier to instill with your own personality as they become less intact and less regular.

creating
balance

Balance is achieved by distributing the weight of the forms evenly around a composition. There are two main forms of balance: *symmetrical* and *asymmetrical*.

SYMMETRICAL BALANCE

Symmetrical balance, in its pure state, means that the composition may be divided into two identical sides. The human form is symmetrical; if divided in half, each side would look the same. Artworks, however, may display symmetrical balance even though they lack mirror-image repetition. Forms with similar size, value and detail may be repeated on both sides of a piece to create equally balanced compositions.

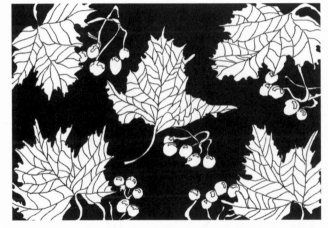

Balance Through Symmetry

Notice that there is equal weight in every corner of the composition so that it remains balanced whether placed vertically or horizontally. The piece could be bisected in any direction and still maintain even weight distribution. Also notice that the leaves and twigs are placed so that they break out of the borders in similar ways.

ASYMMETRICAL BALANCE

A pleasing balance can be achieved even when two sides of a composition are very different. Asymmetrical balance occurs when complementary forms on one side counter-balance dominant forms on the other. One large form may counterbalance several smaller elements; strong light values may counterbalance strong dark ones; a broad, open area may counterbalance an area of intricate detail.

Asymmetrical compositions require the careful placement of each element to avoid looking like chaotic collections of random forms. When used successfully, however, asymmetry can lend your work a sense of energy and drama.

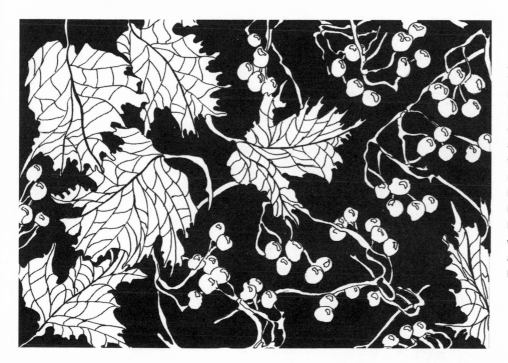

Balance Through Asymmetry

The dominant light values of the left half of the piece are balanced by the dominant dark values on the right, while the sharp, angular forms of the veins in the leaves are balanced by the rounded, curving forms of the berries and twigs. Notice how the leaf placed carefully within the berries and the berries placed within the leaves provide an almost emotional connection between the two forms.

similarity groupings
EXERCISE

Study these branches covered with leaves and berries on the next page. Study the drawing in step 1. It is a simple grouping composed of three basic forms: thin, irregular branches, small round berries and a deeply veined, ragged-edged leaf. Such a grouping may be repeated in a composition to form a pleasing pattern. Repetition encourages the eye to travel around a piece as it seeks similar forms. It also serves to unify a composition with many parts.

Too much exact repetition, however, may result in a work that looks more like wallpaper than art. You can employ repetition but avoid the wallpaper look by using a repeating pattern as the foundation for a balanced, unified composition. By shifting the positions of the repeated groups and creatively altering the characteristics of their individual components, you can introduce variety and imbue each group with a distinct personality.

In this exercise, you'll start with a simple grouping to create two compositions: the first with a regular, repeating pattern, and the second with a freer interpretation of that pattern.

Before you start your composition, cut the drawn forms from the page so that they are separate parts and move them thoughtfully around the picture plane as if they were puzzle pieces. Experiment with different arrangements until you find one you like.

EXTRAS

Black Paper

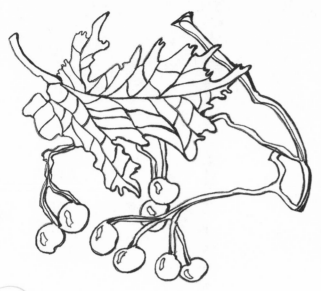

1 Draw and Cut Out a Simple Grouping

Draw a simple grouping: a branch with a leaf and berries attached. Make ten to twelve copies, then cut them out.

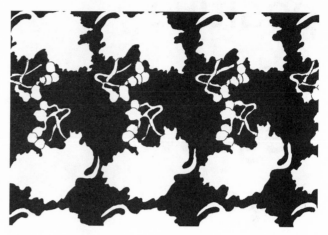

2 Make a Pattern

Arrange the cutouts to create a pattern with regular repetition. Manipulate them like pieces of a puzzle until you find a pattern you like.

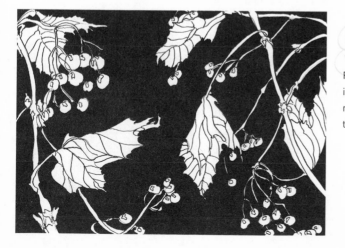

3 Alter The Pattern

Now use your pattern to compose a balanced, unified drawing. Feel free to alter each grouping by stretching, twisting or separating its components. Here, I elongated the branches and the leaves to get a more open, drooping effect. I also gave each form a distinct personality through shape and detail.

positive
and
negative
space

The forms you draw make up positive space, and the space around them is negative space. Good distribution of both positive and negative space is an important means of creating balance. You can create a sense of flow through the relationship between the positive and negative spaces of your composition.

Beginning artists tend to pay too much attention to the positive shapes and not enough to the negative space. Be sure that the negative space surrounding your objects is just as interesting as the objects themselves. Above all, resist placing the subject directly in the center of the page. That's boring and predictable, and it discourages the viewer's eye from moving around the picture. By placing your focal point and distributing supporting subject material away from the center, you can create a path for the eye to follow to ensure that the viewer notices all the elements in your drawing.

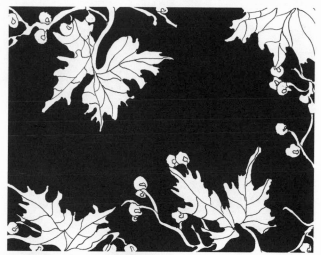

Space is Form

Here are two different solutions to creating balance by utilizing and emphasizing the negative space. Forms should be placed carefully to activate the edges of the composition.

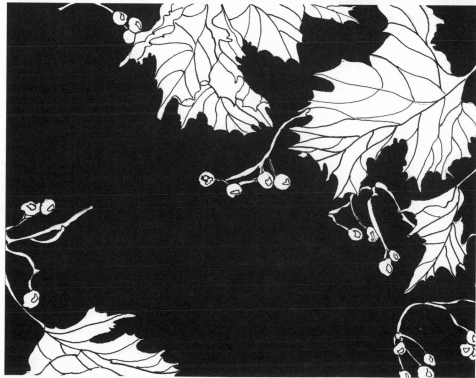

figure-ground **reversal**

One method of exploring the relationship between positive and negative space is by simplifying the composition to black and white. Black is negative and white positive; no grays are required. In such a design, the background becomes just as important as the subject. The goal is to create a design with equal balance between positive and negative areas. Try creating a pattern-like composition, repeating the positive forms while establishing complementary forms within the negative space.

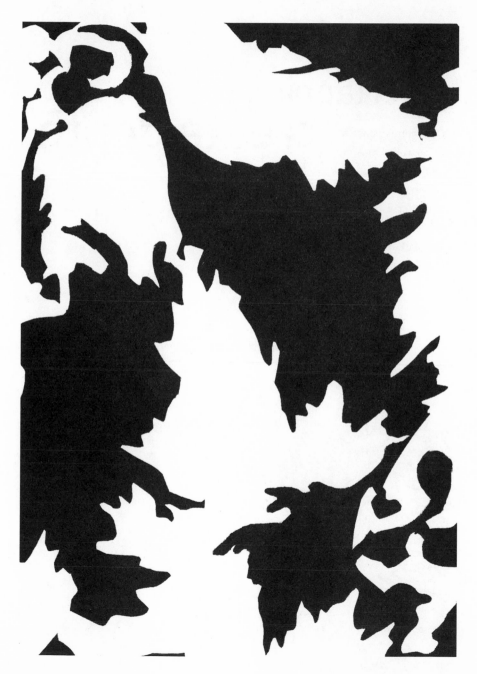

Which Is the Subject and Which Is the Background?

This design demonstrates the kind of figure-ground reversal often seen in fabrics. The positive and negative forms are so equally balanced that it's hard to say which is the figure and which is the background. I call this effect *simultaneous contrast*.

overlapping to **create depth**

One way to create the illusion of depth and dimension in a drawing is to overlap forms. This is an easy way of making one object appear to be in the background, while another comes forward.

When using the concept of overlapping, it's crucial to create a difference between the value and size of both forms. The form in front should be proportionally larger and darker in value than that of the form it overlaps. This will help differentiate them even further.

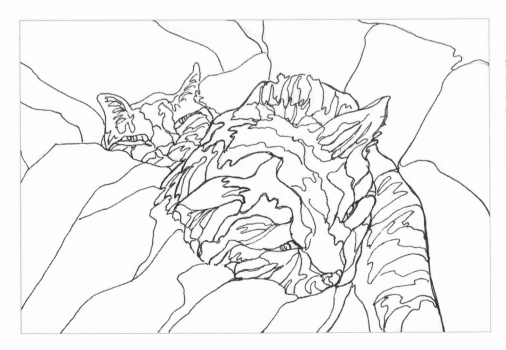

Effective Overlapping

See how Lucy, our little tabby, nestles in behind her brother Jake. Her size and slightly lighter value pushes her to the back. Jake emerges, large in size and dark in value, nearly jutting out of the picture frame.

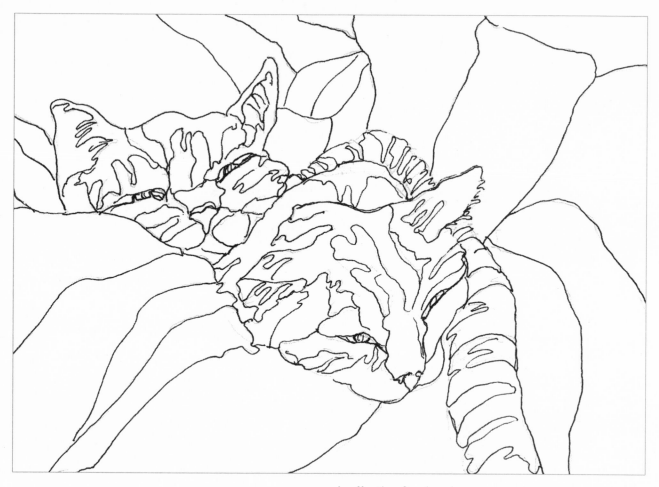

Ineffective Overlapping

Here Lucy vies for dominance with Jake because there is no differentiation between the value of their lines or the size of their heads. The darkness of Lucy's eyes makes her seem to move forward, and the two cats blend into one.

perspective

Perspective is the representation of three-dimensional space on a flat surface. It's the way an artist makes a drawing look as though you could step into it.

LINEAR PERSPECTIVE

Linear perspective is a system that involves using converging lines to suggest distance in a composition. With one-point perspective, all the lines in the picture plane converge at one vanishing point on the horizon. The most obvious effect of this convergence is that objects in the distance appear smaller than those in the foreground.

One-Point Perspective
Objects such as the road in this drawing appear to recede as they grow smaller and their lines converge.

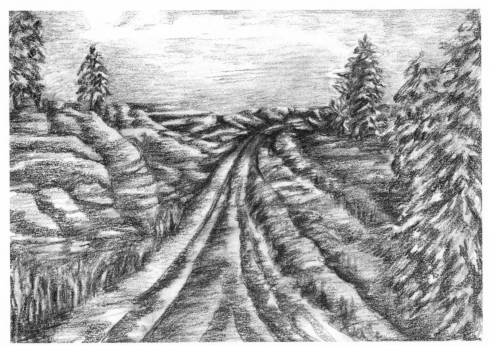

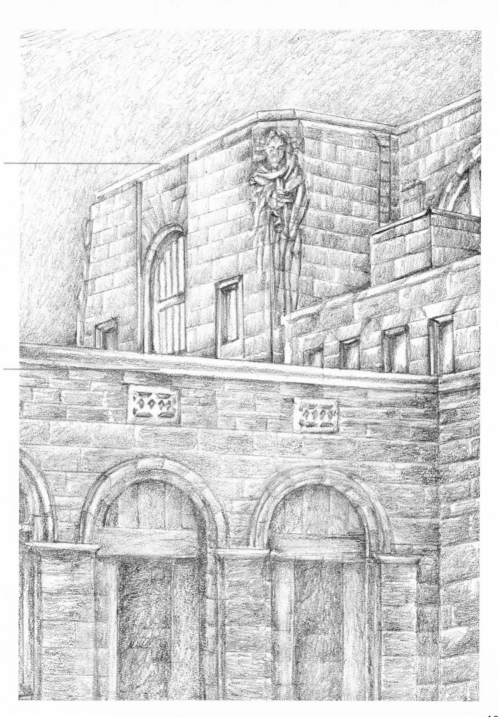

The roof line of the top story recedes to a vanishing point off the paper to the left

The roof line of the bottom story recedes to another vanishing point to the right.

Two-Point Perspective
Two-point perspective involves two separate vanishing points on the horizon line.

ATMOSPHERIC PERSPECTIVE

Our perception of distant objects is affected by the atmosphere through which light must travel from those objects to our eyes. Think of a landscape with mountains in the background. Those distant mountains appear hazy, while objects in the foreground look much more distinct. We can duplicate this phenomenon in our drawings by employing less detail and value contrast for those objects you want in the background, and more detail and contrast for your subjects in the foreground. It's natural to use atmospheric perspective for landscapes, but the same techniques can be applied to more confined scenes, such as still lifes, to add depth and dimension.

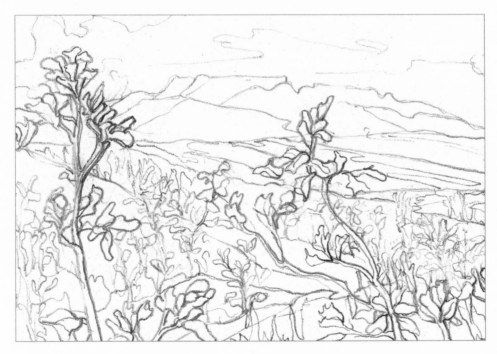

Show Distance With Value and Detail

This contour drawing demonstrates atmospheric perspective. Objects in the foreground are drawn with more pressure (to produce darker values) while those in the middle-distance and background are lighter and less distinct.

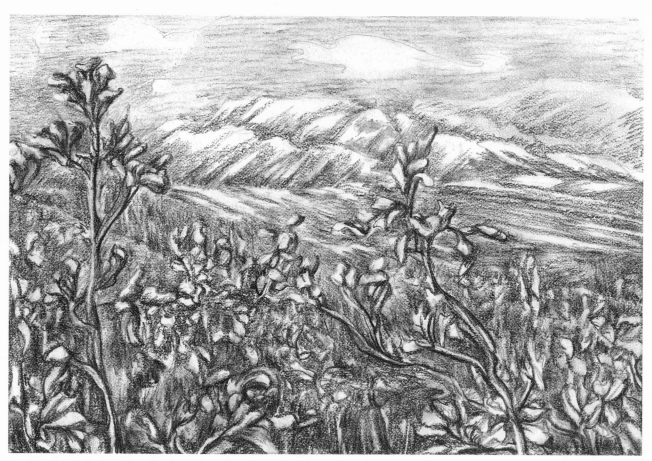

Value Gradations Suggest More Space

The range of value gradations increases the sense of vast space in this scene. Lighter grays are used for the more distant forms as they become distorted by the atmosphere. Bolder contrasts define the foreground subjects as they would in real life.

depth through
details

Diminishing clarity in the details of this scene provides a clue to the dimensions of the hall. The statues become less distinct further back and the human figure defines the scale more accurately. Because we know the general height of a person, we can surmise the general height of the ceiling.

Size Establishes Position
The apparent sizes of the columns and the statues diminishes as these repeating elements recede from the foreground.

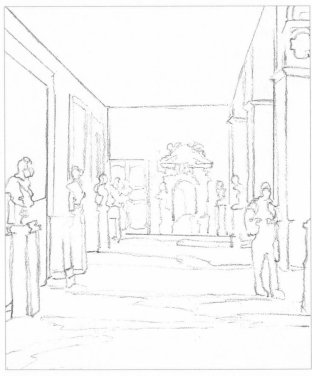

Hall of Statuary

Gradate Values According to Distance

Notice how the statuary in the background is softer in line and less contrasting in value.

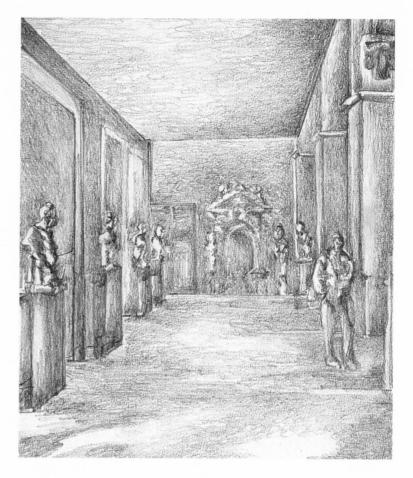

area of
emphasis

Every successful composition directs the viewer to one area of emphasis. It could be an object, a person or a place within the picture plane. Imagine you are a photographer with a zoom lens taking a picture of a meadowlark in a field. The camera allows you to alter reality by focusing on the bird, giving it greater emphasis whether it be in the foreground or background. Another way to emphasize a specific area of the composition is to highlight it by shifting the value range. We already created a value scale depicting the range of white to black from zero to ten. I urge you to develop another scale showing a range of focus or emphasis with the focal point as one and areas of lesser importance rated two, three, four and so on. The focal point should contain a full spectrum of values, with each area of lesser importance diminishing in range of contrast.

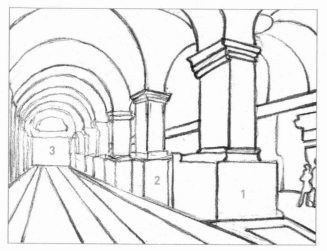

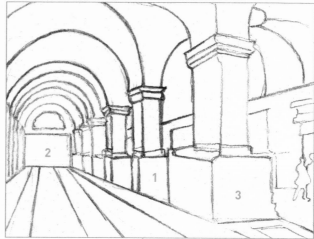

Value Affects Focus

Here are three examples showing how different values can affect our perception and focus. Notice the number sequence. If the focal point is to be in the foreground, that area should be a one on the emphasis scale. If you want the viewer to focus on the background, that area should contain the greatest range of values.

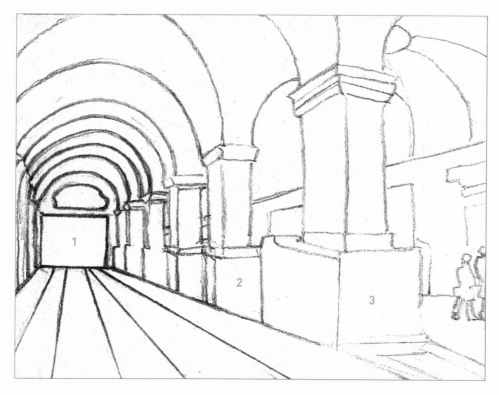

hard
decisions

Dealing with composition issues in your drawings can be frustrating. However, if you will think of a few things before laying pencil to paper, a lot of heartache can be spared. First, what is it you want to say about the subject? Where is your focal point? Which forms do you want to de-emphasize? Where do you want your light source? How is your composition going to be oriented within the borders of the page? Which forms can be repeated to provide balance and unity? Where do you want to place your vanishing points? Once these decisions are made, hold to them. Then you are free to reveal your personality.

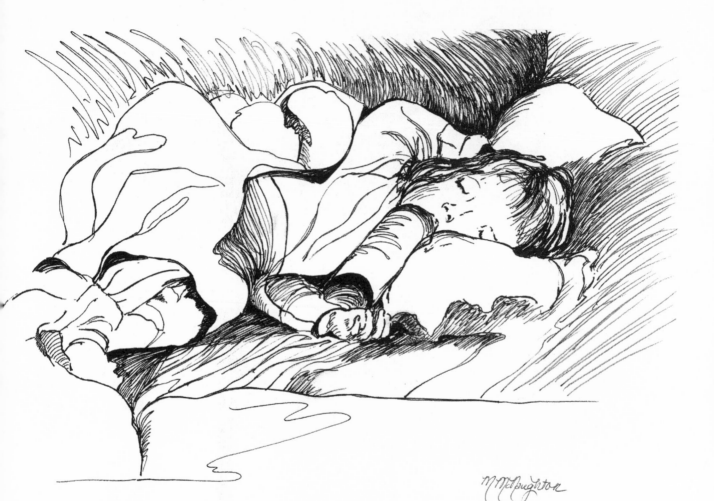

Lauren Asleep

The greatest amount of value contrast and detail within a given area is around the face, head and bottle. It is no coincidence that this is also the area of emphasis.

using what you've learned

MATERIALS

Kneaded eraser

Two to three sticks compressed charcoal

Camera

One medium-tipped black ink drawing pen; two to three fine-tipped black ink drawing pens

Large drawing pad, approximately 18" × 26" (46cm × 66cm)

Conté crayon

Now that you've read about why we draw and learned all the basics of the craft, it's time to put pencil (or pen, or marker, or brush or whatever medium you feel most comfortable and have the most fun with) to drawing pad. Take your materials on location, remember your fundamentals, and sketch what you see in front of you. I hope this section spurs the exploration of new and different settings. Each exercise is a series of two or three drawings that tell a story.

Clipboard that fits the drawing pad

garden series
EXERCISE

A garden conservatory or arboretum would be an ideal location for this series. If you are not near such sites, then a visit to any floral garden will do. Spend some time walking and observing to determine which forms appear "friendly." Remember to examine the surrounding negative space.

Are there unusual repetitive shapes? Does the light create interesting shadows? Are there dramatic differences in the sizes of the flowers? There are limitless possibilities, but stay true to what you want to say in each composition.

Organic forms make great subjects because of their imperfections. You can take liberties with their characteristics and it will matter little to the viewer. If you wish to fit something into the picture plane that isn't actually there, go ahead and put it there. Edit freely from your surroundings. Draw the object in your own unique way.

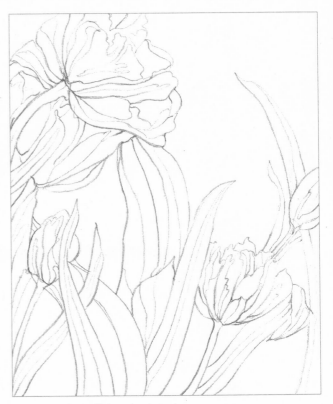

Let Your Eyes Take the Lead
Lock your eyes on the subject and attempt to draw as blindly as possible. Let your hand be an extension of your eyes. The contour drawing should be highly informative; try to capture three-dimensionality. This will tell the story and lay the groundwork for the value gradations.

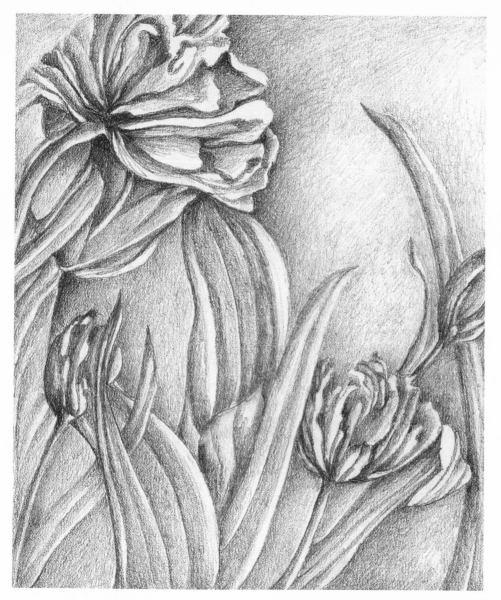

Develop the Subject With Value Gradations

A vertical format allows you to explore the relationship of buds to the mature plants.

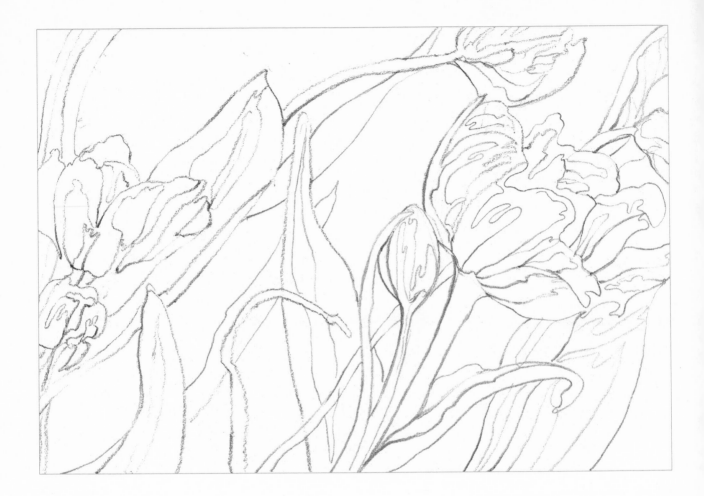

Flowers Reaching to the Sun
Contour lines lay the foundation for the
drawing. Notice how the diagonal lines of
the composition add a sense of movement
and energy.

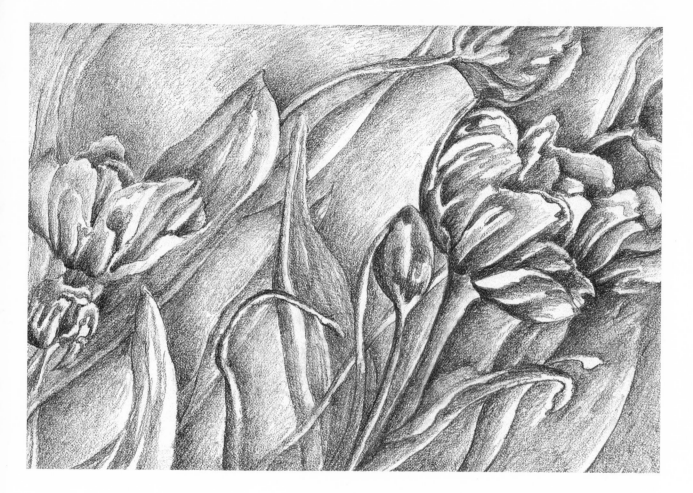

Shadings Add Emphasis
Shading provides value contrasts that
direct the eye to areas of emphasis.

animal in a natural setting

EXERCISE

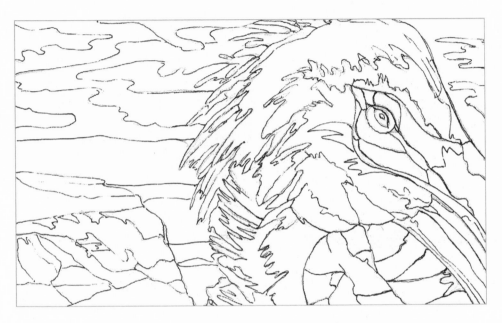

Explore Details in a Closeup

Zoom in to examine the details of the pelican's complexities. In this close-up view, we begin to see how the bird relates to its surroundings. The ink contour drawing gives us all the information we need to imply the depth and texture of the feathers.

No sooner is the perfect composition presented when the dog or cat gets up, stretches, yawns, and strikes a new pose. Therefore, an ideal location to sketch "live" animals is a natural history museum. There you will find lifelike panoramas of creatures in their native habitats. These are perfect places to study surface details like fur or feathers, as well as the structure of the animals and their surroundings.

My students often become weighed down trying to render an animal's surface details perfectly. I recommend developing a "story line" for your drawing by placing the creature within a setting that balances and supports the form. This helps create an emotional connection with the viewer and takes the pressure to achieve technical perfection off the artist. Try a few closeups of different parts of the body to tell the animal's story.

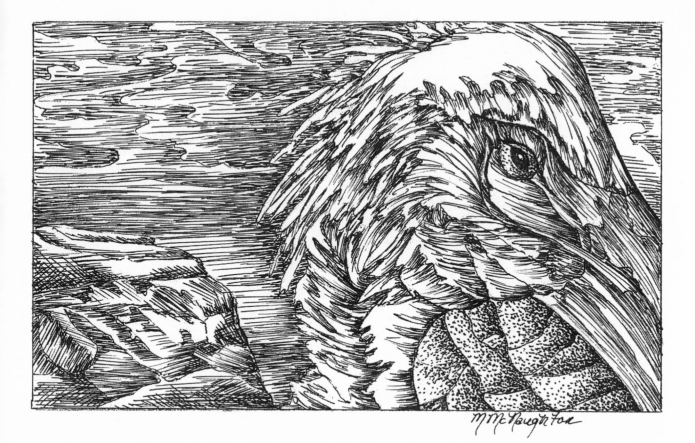

Add Texture

The value gradations are completed in pen and ink. Use hatching and stippling to add texture to the feathers and bill. Rely on the information within the contour drawing to finish the gradations in the water.

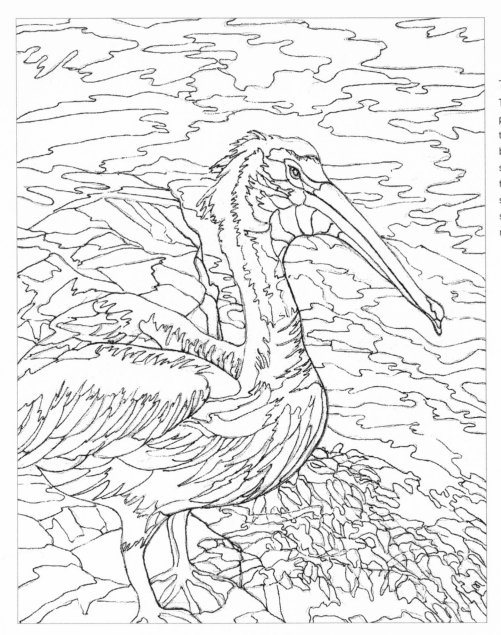

The Importance of Setting
This contour drawing reveals the pelican in a complete setting, but the bird is still the focal point. The background provides balance and subtle movement with the horizontal flow of the water and diagonal sweep of the foliage. Allow the setting to emphasize the subject rather than overwhelm it.

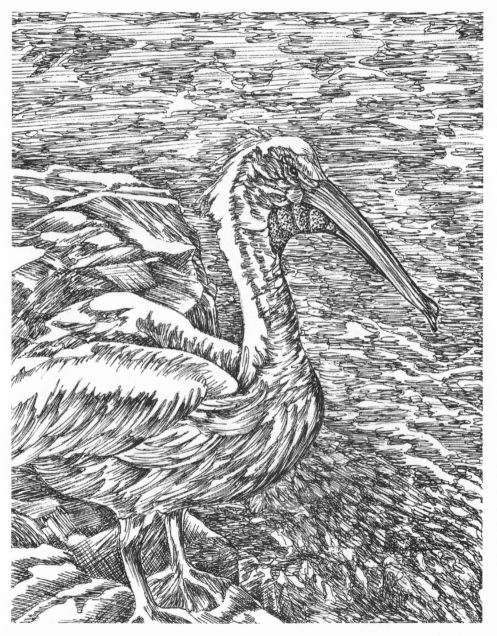

A Force of Nature
Hatching, scribbling and stippling with pen and ink portray texture. Support the contours with textural value, being careful not to overwork the drawing. (I had to complete a few drafts before I achieved success.)

landscape

Landscapes provide a perfect opportunity to work on atmospheric perspective. Ideal locations to dramatize with such perspective are country roads, a field with bales of hay, or a valley with distant mountains. Look for subject matter in the foreground, middle ground and background that can be developed with varying degrees of contrast and clarity to show depth. Decide which of your elements will be the focus, then use size and overlapping to establish its place in the picture plane. Emphasize it with value contrast and detail.

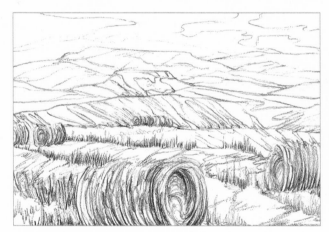

A Fact-Finding Process
Use your contour drawing as a fact-finding process. Contour lines should define areas of highlight and shadow. Use the weight of the line to indicate relative values.

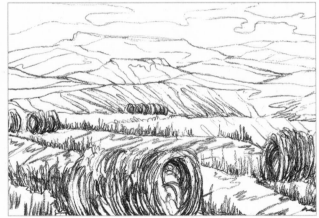

Add Definition
Give definition to the hay bales by adding more value contrast and detail. The relative sizes of the bales and the overlapping of the ridges in the field contribute to the spaciousness.

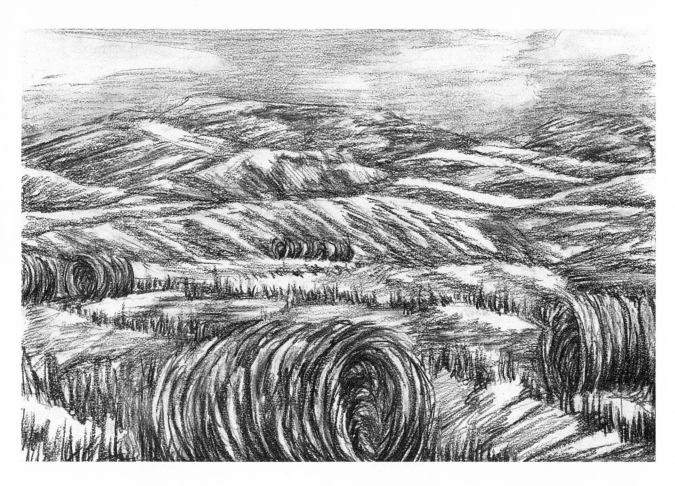

Hay Bales in the Fields of Montana

Once you have developed the basic forms in your contour drawing, you are free to fill in the rich texture of the hayfields with expressive gradation strokes.

the human form
EXERCISE

A good series can be developed from a sequence of actions by the same subjects in the same setting. Focus on the forms and explore different aspects of the scene in separate drawings. Good settings for drawing groups of people in action are public venues such as athletic events, circuses, playgrounds and dance classes. More personal environments for depicting family members or friends include picnics, nursing homes and family reunions. Even more intimate moments could center on sleep, reading to a child, a hug or an everyday chore. Successful compositions usually capture some kind of action, even if it's merely someone gazing out a window. Avoid drawing portraits of a model doing nothing.

Remember to use one light source, edit out the distracting elements, and add any details that might help develop the story.

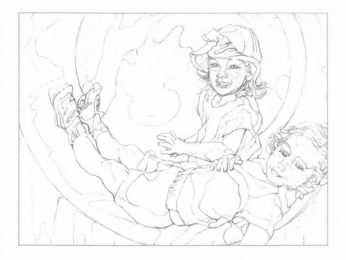

Anna and Clare Thinking About Playing

Anna's body, in the foreground, stretches and curves to fit within the play drum. The contour drawing defines the forms of the bodies as well as their shapes. The thoughtful, contemplative mood of the children is also revealed. The shaded drawing clarifies the direction of the light, using values to develop the facial characteristics and relaxed poses of the girls.

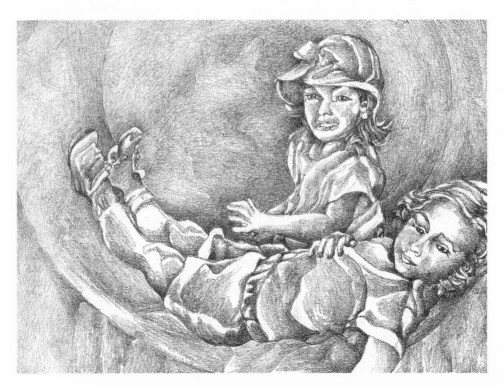

Anna and Clare Start to Play

Allow the contours to reveal the push and
pull of the children beginning to move.
Their expressions suggest anticipation.

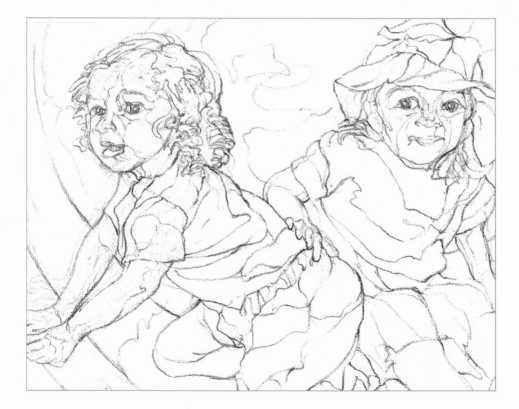

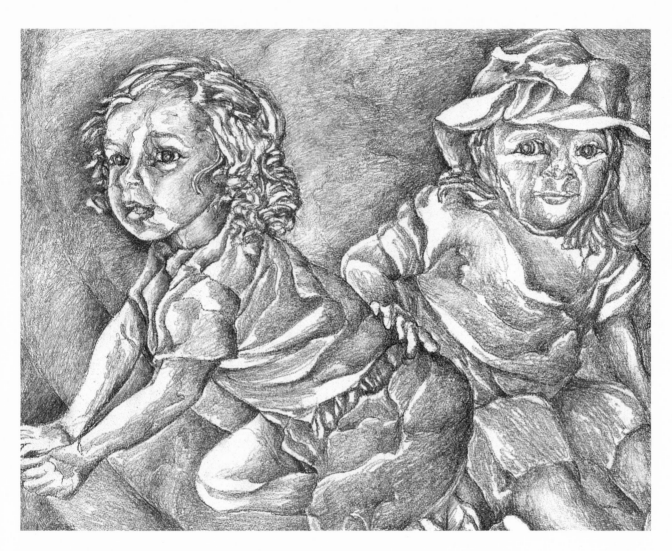

Choose the Best Light Source for the Story

With the light source at the left, more light will fall upon Anna (on the left) than on
Clare (in the hat). Use more value contrast to draw attention to Anna's face. Use
subtler gradations on Clare so that she will recede into the background just a bit.

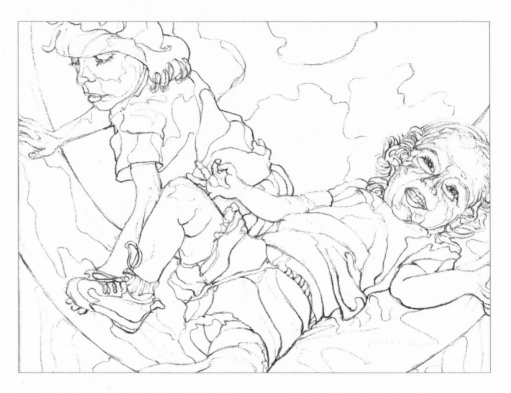

Here We Go!

The final contour drawing displays action. Notice how the placement of the figures causes them to break out of the borders in the direction of their thrusting motions. It's important to de-emphasize the supporting contour of the drum so that it doesn't compete with the human activity. Make the line drawing as dynamic as your story.

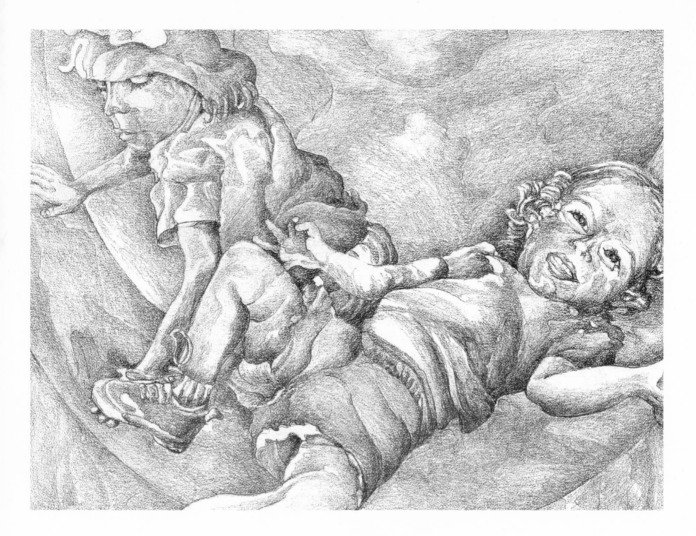

Let the Drawing Shade Itself

Maybe not quite literally, but if your contour drawing has included all
the facts you need before you begin adding value, shading will be easier.
If you jump ahead, you'll most likely get lost. Use value to highlight the
body parts in motion.

architecture in perspective

EXERCISE

Depicting architectural structures demands the use of linear perspective. Choose a location that has some interesting vantage points. I recommend an old church, government or school building; they often have lots of fun angles, and their upper stories may be so far in the distance that you also will have to use atmospheric perspective to realistically portray them.

Try a series with your building of choice. Move from one vantage point to another, perhaps experimenting with both one-point and two-point perspective. Or try capturing the same scene at different times of day or in different seasons for varied lighting effects.

The exercises on the next few pages show architectural subjects from a low vantage point, from a distance to create a cityscape, and from close up to focus on a detail.

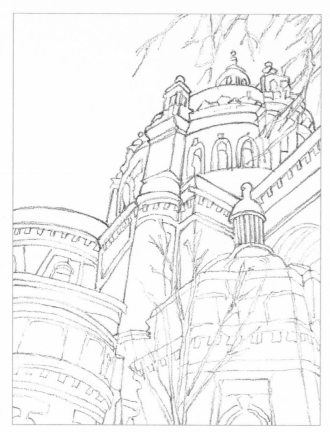

Vary the Line for Emphasis

The contour line evolves from wide and soft near the bottom to sharp and fine at the top, directing our eye to the cathedral's dome. It's a reverse of atmospheric perspective to shift the focal point to my liking.

Foreshortening Provides Drama

A low vantage point provides the opportunity to dramatically foreshorten the dimensions of the building, drawing the eye upward to the dome. Gradually increasing value contrasts also draw attention to that area.

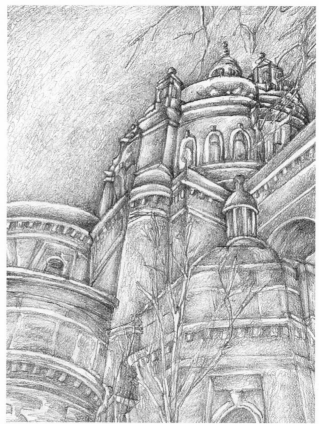

cityscape in perspective
EXERCISE

Sometimes compelling subjects contain way too much detail. Try to not make things overly complicated. Minor elements such as the signs, light fixtures and surface decorations are rarely important enough to include unless they support the story line or provide useful clues for establishing perspective.

Choose a simple, direct vantage point. Allow the foreground to serve as a frame to lead the viewer into the composition. Look for subject elements that can help you establish a definite middle ground and background. Include as much information in your contour drawing as you can before you begin adding shaded values.

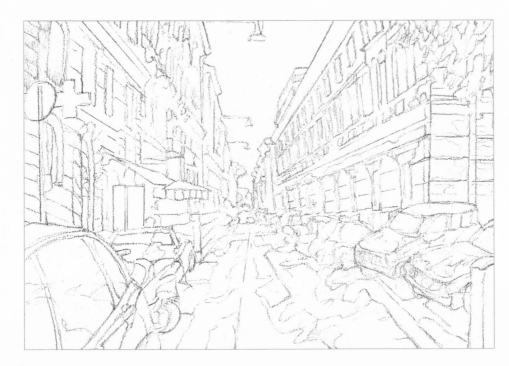

Establish the Perspective
One-point perspective dictates the size of receding forms.

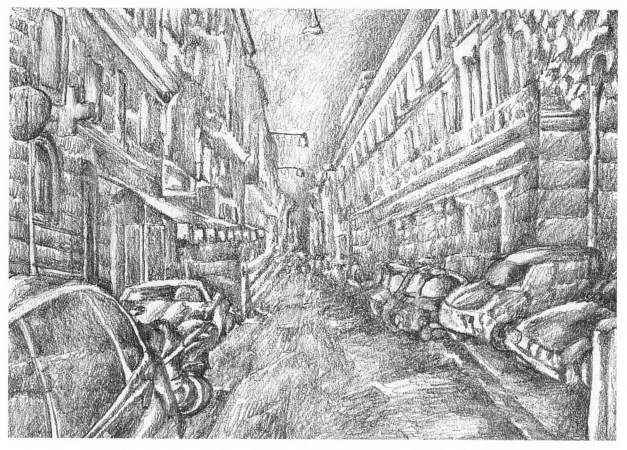

Use Objects to Define Space

The parked cars add to the cityscape as they fit along the narrowing street. The sequentially spaced light fixtures were chosen carefully to move the viewer's eye back in space. Any superficial details that did not contribute to the perspective of the scene were excluded.

architectural details

EXERCISE

Architectural details can make fascinating subjects for your drawings. Find a building that has some type of ornamental sculpture or detailing. Often, these are located over a doorway, a window or in a niche along a wall. They may be found on the interior or the exterior. Explore the relationship between the fluid, curvilinear aspects of the carving to the straight, angular edges of the structure. You may choose to zoom in closely on a portion of the form, look at the detailing from various angles, or portray it at different times of day for lighting variations.

Architectural sculpture is compelling because it is usually unique to the building or structure. Here I've drawn the goddess Persephone, watching over the doorway of McNeal Hall on the University of Minnesota's St. Paul Campus. I like the pleasing flow between the face and the floral forms.

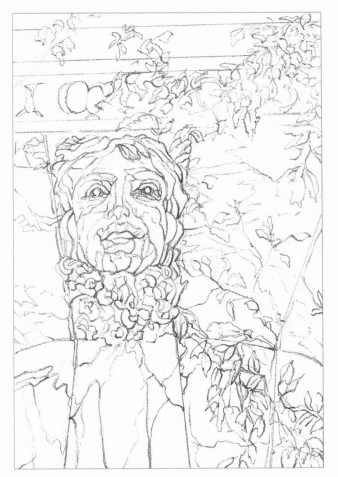

Discover the Flow of the Forms
The similarly organic facial and floral forms are balanced by slight indentations of the stone as well as the firm lines of the building.

Add Form and Depth With Value

Shading reveals Persephone's compelling qualities and provides value contrast to direct the eye.

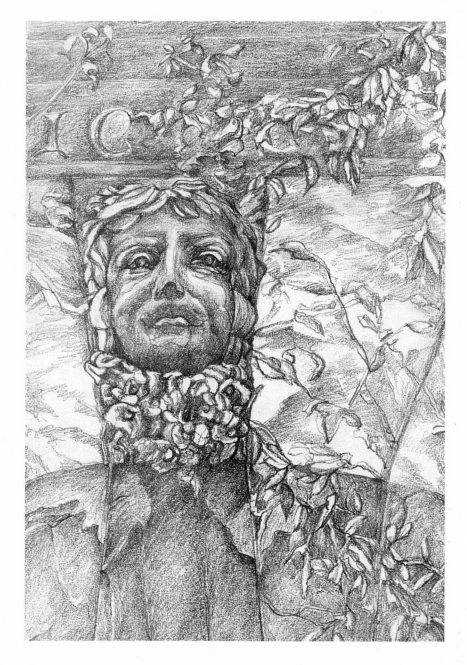

Choose a Vantage Point

This vantage point not only allows the viewer to better understand the connection between the sculpture and the foliage, but also your connection to the subject.

Values Reveal Personality

The dramatic play of light and shadow created by gradations of value further reveal the personality of the subject—and you, the artist.

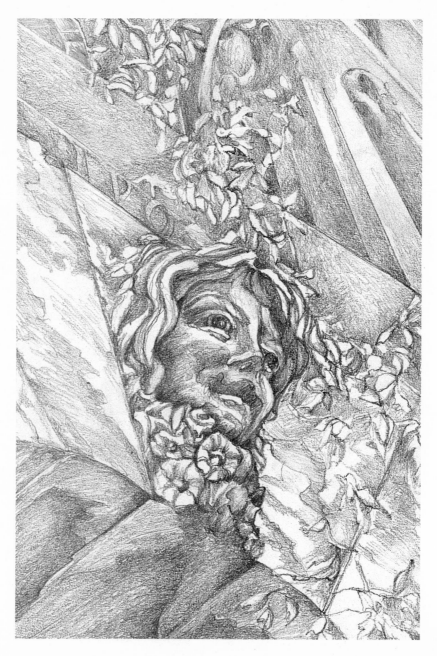

conclusion

By the time you read this final passage, certain skills will have been developed. My goal in writing this book has been to teach the art of drawing in a friendly, understandable manner. I hope my words provided structure, encouragement and empowered you to make wise artistic decisions.

Take a little at a time. Once you learn the basic techniques of drawing, you will be able to pick and choose from the more advanced lessons to fit your personality and interests.

The information within contour lines becomes the key to unlocking the puzzles of drawing. Through exercise and practice, the traits that are unique to each of us can be revealed. The importance of working in serial imagery opens our imagination to new possibilities and ways of thinking. When we look at our subject in only one way we rarely convey our best ideas.

Whether the process involves different mediums, techniques or viewpoints, each composition will lead you to a path of self discovery. Think of your first pieces as exercises. Feel free to experiment, make mistakes and learn.

More often than not, we take the sensible route in choosing vocations. Even though we ache to explore our creative sides, we deny ourselves the opportunity. We then wonder why we become disillusioned and unhappy in our daily lives. I see many frustrated students looking to be whole again. It doesn't have to be an either/or situation. Take the chance to know yourself through drawing and enjoy your journey. Use this book for encouragement and, hopefully, some insight.

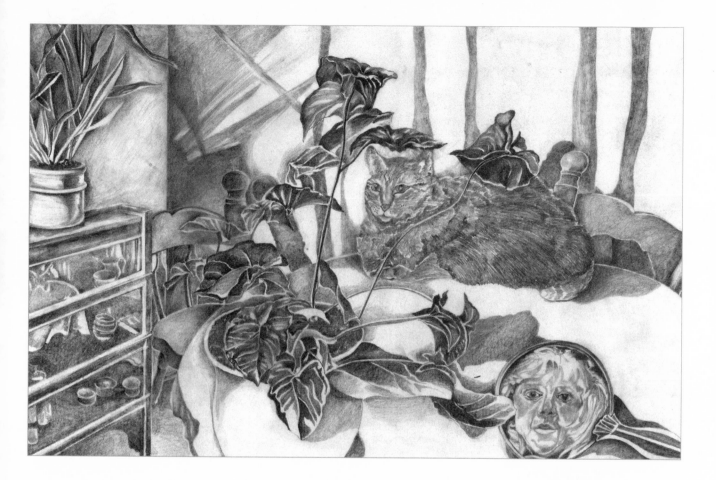

index

The best in drawing instruction comes from North Light Books!

ISBN-13: 978-1-58180-757-8
ISBN-10: 1-58180-757-0
Hardcover, 192 pages, #33424

Discover new ways of working that free your creativity! Every artist wants to be more creative, and this book demystifies that often confusing process. There are over forty exercises to help you unlock the power of the imagination and learn how to recycle old drawings into fresh ideas.

With fun exercises, expert instruction and a gallery of inspiring examples, artists of all levels will come away more confident and creative!

ISBN-13: 978-1-58180-811-7
ISBN-10: 1-58180-811-9
Hardcover, 128 pages, #33494

While most drawing books provide methods for analyzing subjects and simplifying them into easily digestible forms for drawing, they don't address the most common problems the reader confronts or the skills he or she already possesses to overcome those problems. Drawing With Your Artist's Brain uses an interesting, unusual and proven approach to employ what the reader already knows to become a better artist. More than twelve step-by-step drawing demonstrations, multiple exercises and tip sidebars provide the instruction you need to drastically improve your drawing skills.

ISBN-13: 978-1-58180-861-2
ISBN-10: 1-58180-861-5
Hardcover, 144 pages, #Z0271

Most drawing technique books hinge on the approach of one person, but this compelling collection gives readers the chance to learn from more than 100 talented artists. Each gorgeous drawing selected from over 3,000 entries is accompanied by insightful comments from its creator. Drawing is foundation of every great piece of art and artists are eager for a book celebrating that fact. This essential guide shows artists at every level how to sharpen their drawing skills.

ISBN-13: 978-1-58180-789-9
ISBN-10: 1-58180-789-9
Paperback, 128 pages, #33465

Absolute beginners and those looking for a refresher course will find this book to be a wonderful tool. The authors, Mark and Mary Willenbrink, have created a series of exercises which take you from the basic fundamentals of drawing to the complexities of creating landscapes, still lifes, people and much more. With encouraging words and an emphasis on having fun, each exercise is designed to build confidence. Complicated concepts are explained clearly so that even the novice will be inspired to try. Before long, you will find yourself drawing with a confidence you never imagined!

These books and other fine North Light titles are available at your local fine art retailer or bookstore or from online suppliers.